Please re

F
b
ir
by

CALUM COLVIN was born in Glasgow in 1961 and is Professor of Fine Art Photography at Duncan of Jordanstone College of Art and Design, University of Dundee. Colvin's artworks have been widely exhibited in venues as diverse as Orkney, Los Angeles and Ecuador. A practitioner of both sculpture and photography, Colvin brings these disciplines together in his unique style of 'constructed photography': assembled tableaux of objects, which are then painted and photographed. His complex compositions are rich in association and spatial ambiguities. As well as being visually exciting, humorous and intriguing, Colvin's work demonstrates that the art of the past is relevant in a modern society.

His work is held in numerous collections including the Metropolitan Museum of Modern Art, New York; The Museum of Fine Art, Houston; The Victoria and Albert Museum, London as well as the Scottish National Portrait Gallery, Edinburgh and the Gallery of Modern Art in Glasgow.

RAB WILSON was born in New Cumnock, Ayrshire in 1960. After an engineering apprenticeship with the National Coal Board he left the pits following the miners' strike of 1984–5 to become a psychiatric nurse. His work has appeared frequently in *The Herald* as well as *Chapman*, *Lallans* and *Markings* magazines.

Rab has performed his work at the Edinburgh Fringe Festival, the StAnza poetry festival at St Andrews, the 'Burns an a' That Festival' at Ayr and has been 'Bard of the Festival' at Wigtown, Scotland's National Booktown. Additionally Rab is a previous winner of the McCash Poetry Prize. In 2013 he was the first 'James Hogg Writer in Residence' and was formerly 'Robert Burns Writing Fellow – in Reading Scots' for Dumfries and Galloway Region. Currently a member of the National Committee for the Scots Language Resource Centre, Rab regularly attends the parliamentary Cross Party Group for Scots language held at Holyrood. He is a passionate advocate for Scots writing. He has recently moved back to New Cumnock, where he now lives with his wife Margaret and daughter Rachel.

By the same authors:

CALUM COLVIN

*The Seven Deadly Sins and the Four Last Things*, text by Tom Normand (Portfolio Gallery, 1993)

*Sacred and Profane*, text by James Lawson (The National Galleries of Scotland, 1998)

*Ossian: Fragments of Ancient Poetry*, text by Tom Normand (National Galleries of Scotland, 2002)

*Natural Magic*, text by Tom Normand and Prof Nicholas Wade (Royal Scottish Academy, 2009)

RAB WILSON

*The Ruba'iyat of Omar Khayyam in Scots* (Luath Press, 2004)

*Accent O the Mind: Poems chiefly in the Scots language* (Luath Press, 2005)

*Life Sentence: More poems chiefly in the Scots language* (Luath Press, 2008)

*A Map for the Blind: Poems chiefly in the Scots language* (Luath Press, 2011)

# Burnsiana

*Artworks and Poems*
*Inspired by the Life and Legacy of Robert Burns*
Artworks by Calum Colvin
Poems by Rab Wilson

**Luath** Press Limited
EDINBURGH
www.luath.co.uk

## PICTURE CREDITS

p17 Poosie Nansie's Inn: Douglas McKenzie.

p18 'Ellisland' by J. Ramage, engraved by A. Willmore from *The National Burns: Burns Works, Vol 1* ed. Rev. George Gilfillan (published by William MacKenzie, London, Edinburgh & Glasgow, circa 1880).

p22 One guinea note with a poem by Robert Burns, 1780: Robert Burns Birthplace Museum, Alloway (National Trust for Scotland).

p39 *Bottom Photograph.* Armorial binding of a French translation of Macpherson's *Ossian* from Napoleon I's library at Fontainebleau: National Library of Scotland, NLS shelfmark Bdg.s.720.

p41 *Top Photograph.* Scott Monument: Shutterstock.

All other images: Calum Colvin

First published in 2014

ISBN: 978-1-908373-91-5 (hardback)
ISBN: 978-1-910021-01-9 (paperback)

The paper used in this book is recyclable. It is made from low chlorine pulps produced in a low energy, low emissions manner from renewable forests.

The publishers acknowledge the support of

ALBA | CHRUTHACHAIL

towards the publication of this volume.

Printed and bound by DS Smith, Glasgow

Typeset in 11 point Quadraat by 3btype.com

# Contents

## Acknowledgements

I would particularly like to thank a few individuals for their support in the creation of this book, especially Dr Tom Normand from the University of St Andrews, who was particularly generous with encouragement and advice. I must also thank Janice Galloway for her kind words in the Foreword. Thanks also to Gavin MacDougall and all at Luath Press.

The Robert Burns Birthplace Museum in Alloway first hosted the 'Burnsiana' collection of artworks from June-Nov 2013, and I would like to especially thank Sheilagh Tennant (Curator) and Nat Edwards (Director).

For technical assistance Kenneth Caldwell at Being There Media and Elizabeth at Ayrshire Agencies provided much-needed recording and transcription services.

I pride myself in being the world's slowest photographer and the work in this book has been created over a long period of time. This has involved the assistance and generosity of many individuals and organisations, too many to mention here in full. However, I would like to extend my thanks to Julie Lawson at the Scottish National Portrait Gallery and Cathy Shankland at Highland Region for their support in the creation of this work over the years.

## Foreword by Janice Galloway

## A lad o pairts

> I don't know if you have a just idea of my character, but I wish you to see me as
> I am. – I am, as most people of my trade are, a strange wil o' wisp being;
> the victim too often of much imprudence and many follies. – My great
> constituent elements are Pride and Passion: the first I have endeavoured to
> humanise into integrity and honour; the last makes me a Devotee to the
> warmest degree of enthusiasm in Love, Religion or Friendship...

These are words Burns wrote about himself. It's a consolation after hundreds of years of bottling the man, trying to pin him down, that the man himself understood he was more than just one thing.

Calum Colvin's blends – the photographic and the painterly, the traditional and surreal, the lasting and the ephemeral – have fascinated me from the first time I clapped eyes on his work. It was a portrait of James MacMillan, the stellar contemporary composer from Cumnock, Ayrshire: his face made of a perspective 3D trickery of objects that invited the onlooker's collaboration in assembling the disparate parts into the man. It was on exhibition in Edinburgh, the article said. I got my coat.

There, I found not only one Ayrshire boy but two. Beside MacMillan, another musician as stellar as they come: misunderstood, misaligned, shamelessly misappropriated by the Heritage industry, but whatever they did to him, wholly recognisable. It was Robert Burns.

I grew up in Ayrshire so knew Burns as only a child from Ayrshire can: way too little, too reductively and for just one thing. He was who you did once a year for the school poetry competition whether you liked it or not. 'To a Mountain Daisy' (served up as no more than a ditty about a flower), 'Address to a Haggis' (served up as serious). Burns, in other words, reduced, hog-tied, compulsory.

What Burns actually *meant* as opposed to signified to the national psyche took much, much longer for me to unravel. It involved reading the man's own words about himself as well as the poetry *as* poetry, not shamanic slogans. It involved reading him as a working author and man of his times like no

other. It involved fiercely reclaiming him from a hundred tartan shortbread tins – and I was glad, glad, glad I did it. Burns, afresh, was a liberating discovery.

Seeing him through Colvin's eyes was that fresh discovery all over again. Like a fine novel or an excellent collection of poems, the work suggested new ways of seeing not only the subject but the subject's context, the mythology grown around him without his compliance, and a homage to what might be the sum of these parts. This collection begins with Burns and wraps its arms around Burnsiana as bastard children the poet himself never conceived. Through everything, Burns rises serene, waiting for us to make him into something whole.

Notoriously devout *and* rebellious; crude *and* tender, acutely aware of his lack of social standing *and* cocky; sure of his talent yet apprehensive of his ability to succeed, Burns is not so much a mass of contradictions as a mass of unresolved energies. Calum Colvin shines light not only on this but on all that surrounds it. In the increasingly fraught run up to our votes being cast for Scottish Independence, Now is indeed the Day, and Now indeed the Hour.

How are we to find meaning in the complexities of our histories? How are we to interpret the melancholic past, acknowledge the present and aspire with honour, not cheap sentiment or mock heroics, to the future? Burns asked these questions. Calum Colvin reframes them now.

The Bard himself is beyond caring what we think of him, if he ever did. What he'd prefer we care about is the work, its speaking to us. The tangle of the deeper, darker, childish heart. The wonderfully multi-layered work in this collection, as direct as it is allusive, is a great way to begin the process of that rethinking.

Janice Galloway

## Preface

As Janice Galloway has so eloquently described, there are a multitude of ways of encountering/de-constructing/envisioning the world of Robert Burns. My background research in this area has taken me to many places, meeting numerous people whose expertise on Burns has been an invaluable aid toward the creation of these images. These people include historians, academics, actors, writers, scientists, curators, artists and, not least, poets.

I first encountered the poet Rab Wilson's work when I was researching contemporary reciters of Burns poems for my work 'Portrait of Colin McLuckie'. I was pleased to see him recite Burns and some of his own material alongside John Cairney at the Edinburgh Festival in 2012. I was impressed, and when Gavin MacDougall suggested Rab as the poet to collaborate with on a book of my Burns imagery, it seemed entirely the right thing, and I was delighted when he agreed.

I see my pictures (my paintings/photographs/sculptures) in some sense as objects of contemplation, starting points on visual narrative journeys, hoaching with *double entendres*, visual puns and symbolic associations. I was keen Rab would envision the pictures for himself, simply absorb the work, then produce a poetic response to the visual material in his own voice.

I think he has done that effortlessly, and with great humour, intelligence and tenderness.

*Calum Colvin*

## Introduction

Calum Colvin invited me tae write poetic responses tae his new exhibition 'Burnsiana'. This wis an excitin an interestin challenge tae create poems based oan Calum's intriguin, original an inspirational artworks. There is a kind o 'three wey' ekphrasis takkin pairt here; Calum haes bin inspired bi ither artworks, objects, images, characters, etc tae create his art; nou Ah hae bin inspired bi his creations tae produce yet anither layer o art (the poems) – sae that the 'multi-layered' aspect o Calum's wark nou reaches oot intil yet anither dimension, the imaginative recesses o anither artist's mind, tae add yet mair layers tae this fascinatin project!

*Rab Wilson*

Byron's comment upon reading some
of Burns' letters:

They are full of oaths and obscene songs.
What an antithetical mind! – tenderness,
roughness – delicacy, coarseness –
sentiment, sensuality –
soaring and grovelling,
dirt and deity –
all mixed up in that compound
of inspired clay!

## Calum Colvin, artist, interviewed by Rab Wilson, poet

The following narrative is based on a conversation recorded at the Robert Burns Birthplace Museum in Alloway in July 2013, where an exhibition of the artworks by Calum Colvin in this publication was on display. The artist and the poet discuss aspects of the pictures as they move between the works on the walls. The exhibition title (and also title of this book) *Burnsiana* is a word which does not appear in any dictionaries. However, it's generally understood to loosely refer to any collection of literary odds and ends relating to Robert Burns. For this exhibition this has been extended to also encompass a visual representation of these 'odds and ends'. Colvin's interest in Burns is longstanding and, in this exhibition, on display was a collection of Burns related work created over the last thirteen years.

Rab Wilson was in the process of composing the poems for this book in response to the artworks, and this conversation reflects their thought processes in this collaboration.

RAB: '*Burnsiana*'. Sae, hou did the hail thing come aboot?

CALUM: The project evolved from an invitation from Sheilagh Tennant (Curator at the Robert Burns Birthplace Museum) to make an exhibition of Burns-related material for this Museum, but Burns, as a subject, for me, goes right back to 2000, when I made my first Burns portrait. Over the years, I have intermittently returned to the subject, creating images related to Burns, or Burns poetry, related to Burns country if you like. And that's what suggested the title, *Burnsiana*, because it suggests the industry of Burns related material that has proliferated in the years since the Bard's death. This cult of *material culture* has fascinated me for a long time, particularly after I acquired a copy of the publication *Burnsiana* (1988, Alloway Publishing) by James A. Mackay, when I first began to appreciate the large diversity of material.

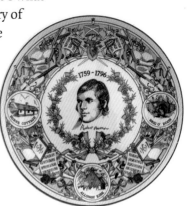

RAB: Aye, ephemera an collectables an stuff lik that.

CALUM: Ceramics, glass, stamps, woodware *et cetera* I have used these over the years as a kind of reference point, a

beginning for an image, or a detail in an image. What draws me to these kinds of objects is the potential for new narratives, subverting them towards another image and/or object that might reflect further thoughts/associations in regard to the world of Burns and the resonance of these things in, and on, the general culture. It's fundamentally about transformations and metamorphoses, and this has been an underlying aspect of my work generally.

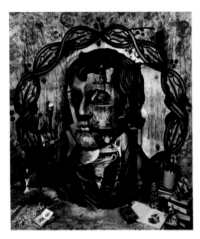

RAB: Because eftir Burns' death in 1796, Ah mean, the hail industry quickly taen aff an throu the hail o the 19th century, there is aamaist this hagiography o Burns – he becomes this kindae mythical King Arthur-type figure, an aa the kitsch stairts gettin made. Fir example, in the picture here, ye've goat an item o Mauchline ware, these buiks an objects aa made o wuid, or 'treen' as they're kent. There's a huge, collectable market in these things – cups, thimbles, you name it, things aa made in Mauchline ware. Sae, throu that hail century an ayont, the world hus been flooded wi images o Burns. He must be yin o the most weel kent faces oan earth.

CALUM: Burns, Elvis, Marilyn Monroe – people like that – there's not many of them. And you're right, these are global figures with a global presence, and that's partially what intrigues me. Also, the interesting thing about that is the sense of the early death, maybe that's something to do with it, or somebody that had such a mercurial career, and this difficulty to place when alive becomes much easier in death – and much safer, I suppose, in death.

RAB: Oh aye, aye. Ah mean, we're nou constantly prentin an perpetuatin a legend, an there's that big mural ben the Museum, thon weird version o the Last Supper, an Burns is centre-stage, an ye've goat Elvis there at the table, an ye've goat Marilyn Monroe, ye've goat Mahatma Gandhi, ye've goat Einstein, ye've goat John Lennon – ye ken, there's aboot ten or sae o the maist famous faces in the history o the warld, an there's Burns sittin in the middle, haudin court! An their nae dout he fully desairves tae be in sic exaltit company.

CALUM: Well, it's a fascinating thing – Burns' very particular language [Scots]

used by, let's face it, in worldwide terms, such a small number of people becoming a vehicle for so many ideas and so many shared thoughts on humanity. As an artist, I want to defamiliarise objects and hopefully, make people reconsider their context within the subject. So, for this work, *Burns Country*, the initial impetus was principally that I wanted to make a ceramic plate as a piece of folk art. A lot of ceramics and pottery were made from the early 19th century onwards, and I began to think, well, as we now have the technology to digitally print photographic images on virtually anything – you can print on t-shirts, on ties, mugs, all kinds of things – here's an opportunity to make ceramic plates in a new way, but to fit within a canon of existing visual ephemera. That idea very much appealed to me, so hence the structure of this image lends itself to a circular format.

RAB: Aye, there's an unbroken line here frae the daith o Burns richt throu the 19th an 20th centuries, his Mauchline ware tae the praisent day, an nou you're producin yer ain response tae Burns, an addin anither stane tae the muckle cairn that hus become the hail Burns 'industry'. It's great that the exhibition's here in the new Burns Museum and Burns Country itsel. Ah mean, you approached me tae write the poems as responses tae the pictures an Ah hae been workin oan that, sae that nou Ah've goat maist o thaim written. Just a month or sae ago, ma wife Margaret an masel hud been in Mauchline, at the Annual Holy Fair Gala Day, an there is nae dout Burns wid hae recognised the kindae ongauns there that day; aa the fowk comin thegaither fir a big social event. The great and the guid wir there; the local cooncillors an the politicians, but alsae the ne'er-dae-weels an the drunks an aa the chancers, an then we went intae Poosie Nansies Inn, a howff that Burns kent weel himsel, an whaur he drank wi his cronies, an when we walked in, there wir aa the Mauchline Burns club fowk, an yin says 'Ye're there Rab, come awa intae the snug!', so there we wir in this wee room, tiny wee room, aboot twenty fowk packed intae it, an a boy wi a guitar an evribody jist singin! An o coorse, we've goat a guitar here in this picture! Sae the poem for Burns Country wis based on this whole sort o social riot that still gaes oan at days lik the Mauchline Holy Fair! An luikin at aa the scenes that wir gaun oan there Ah then sort

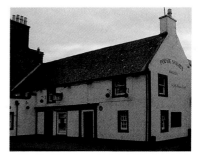

o aamaist hae Burns gaun back an forrit in time in the poem, as if ae meenit he wis pairt o oor era, an then takkin him oot o it agane, an we hud the boy in the snug wi the guitar singin aa the while ane o the great Burns songs, Ah pit a line frae the song intil ma poem; 'The Catrine woods were yellow seen'. Ah luve aa the imagery o the wildlife here tae, especially the birds, Ah mean, Ah tak it that wis a deliberate kindae thing, tae include aa these birds an animals, because Burns' work is hoachin wi images frae nature.

CALUM: Yes, the initial idea of *Burns Country* made me think of two things – the album by Elvis Presley called 'Elvis Country' and it also evokes the rural idylls and scenes you often see engraved in Burns' editions, with maybe Burns or Ossian, a Bard figure, within a landscape, that was a starting point, in a sense, with this background in the picture – which is really just a wallpaper mural – and then this image of the Bard, painted over a guitar.

The birds, this reference to wildlife, suggests the native and the exotic, and I often frame Burns in this way. Burns being of his time and of his people but being essentially an oddity because of his extraordinary gift, he would be an

oddity in any society at any time – warbling his native woodnotes wild. That's what fascinates about Burns, and the scenario you've described. It is a village life that still exists in Scotland to this day, it is a scenario I recognise from my own childhood, having grown up in the countryside. So that culture is alive in those characters, all that stuff is still there.

RAB: An it's a gift tae a writer tae work wi these pentins o yours because they're aa just sae fou o imagery, ye know, an even nou, luikin at it close up, Ah'm seein things that Ah didnae notice afore; Ah didnae notice the wee plough... that wee plough doon at the bottom there.

CALUM: It takes time for the details to reveal themselves to the viewer sometimes. There is an idea of found poetry implicit in the work. And a lot of references, literary, historical and contemporary, often visual, puns. There's a

line in an Elvis Costello song 'like a chainsaw running through a dictionary' ['Our Little Angel' (1986)]. In this instance an ornamental plough going through a dictionary! The idea is of Burns composing whilst working.

RAB: Aye, ye've goat aa the wee bits and pieces here – the moose in its nest, mibbes aboot tae be disturbed wi that plough, a reference, a visual reference tae Burns' 'To A Mouse' poem. There's jist sae much, there's sae much gaun oan in the picture!

CALUM: There's a lot, and these images are made to be read on many levels. There always has been in my work a kind of literary connection, 'defamiliarisation' is a literary device for example but, visually, you read this image from a distance – as we came in the door here, you see a canvas, and you think, oh it's a painting, and then you come closer and you see the detail, the fragments of text and you begin to realise, actually, this isn't a painting, this is a photograph of a painting, but it's also a sculpture, so it's all these things. The idea of moving from the big picture to the detail, the reading of the work, that's very much wrapped in the form of composition of each of the pictures in this collection.

RAB: The actual objects in thaim, these are objects that you hae – some o thaim wull be real objects, some o thaim mibbes frae yer memory or imagination or some that ye've growne up wi fae childhood? The great thing about an artist is that it disnae need tae be a real object, it can be somethin that ye think ye remember frae childhood, an ye re-imagine that for the picture, or jist invent. Sae, are there things lik that here in front o us – things that are real things and things that are just resurrected frae memory, or are pure inventions o imagination?

CALUM: Well, they are all essentially real objects. I mean that in the sense that these are objects in a constructed set for a photograph, but they are also evocative of memory and of time. I try to make my pictures in terms of the style of the objects that fit in them, I try to play with that, so they're not too modern and they're not very old-fashioned. For me, they are evocative of childhood memories, of things that my family, my grandmother would

perhaps have and, again, to me, it suggests Scotland 30 or 40 years ago – the type of objects that people would have on their mantelpiece, in their living room. Of course they must also function as formal compositional devices. It must be like writing a poem? I'm not a writer, so I don't know, I'm guessing – but I suppose you start with a structure and then you bring these ideas and you hang them on different parts of the composition?

RAB: Oh aye, ye hae tae fix oan somethin. In fact, weel, it's lik Michelangelo luikin at the block o marble and seein the statue o David, ye know, before a blow hus bin struck wi the chisel, that's hou ma art evolves. Ah've goat tae luik at these pictures fir a while an luik at aa the things that are gaun oan an then sayin, well, where is the angle ye stairt frae, where dae ye mak the first cut, where's it gonnae come frae? And ye never ken that at the stairt, it can percolate in yer brain fir weeks an then, aa o a sudden, ye get the spark and ye see something, an that's the key that'll open the door to this poem or this picture here fir me.

CALUM: Yes, that's right, and that can come to you quite kind of unexpectedly. These ideas. Sometimes if you try and hunt something down too steely-eyed, you just can't pin it and then you wake up in the middle of the night and you think – *that's* what I need to do.

RAB: Ach, Ah try no tae worry aboot thae kindae things. Ah don't think Ah ever really did. Ah think some people dae, some people get writer's block or they just get stuck, ye know, but Ah've never been stuck yet, an Ah think ye would be a puir writer indeed if ye goat stuck wi these pentins o yours, cos there's just sae much tae draw oan there, but ye still need tae figure it oot, hou ye're gonnae dae it, an different writers wid dae that in their ain wey. Wan o the things wi masel, o coorse, is that Ah dae write predominantly in Scots, in Scots language, in the language o Burns, sae tae write, tae tak the imagery frae the modern Holy Fair in Mauchline an write in a vernacular Scots, still relevant an uised bi the people today, Ah think gies it an extra virr, an extra strength that it sometimes lacks in English. An when ye read somethin like that in Scots tae local people in Ayrshire, or aa ower Scotland, it jist brings a smile tae their face, they ken that's oor language, an they get somethin mair fae that – Ah don't know why that is, but they dae seem tae get somethin mair fae it.

CALUM: Well, it's *the* language, it's such a poetic language. In regards to the

work that I made over the years that are now brought together in this show, it's very apt that the poems, the responses are in Scots. It seems strange to me now not to do that.

RAB: This picture here – 'Twa Plack' – it wis interestin, the concept o 'Twa Plack', these very low-denomination coins that arenae worth verra much at aa. It's as if it's some kindae comment oan that negative view some Scots tend tae hae aboot their ain country? An Burns certainly uises nems o coins an the values o coins in his poems quite a bit, sae luikin at this yin, it seemed that the original concept stemmed frae this idea durin the bicentenary o 1959, where there wis a ploy tae hae a stamp issued bi the Royal Mail tae commemorate Burns an, o coorse, this wis turned doon bi the government; it jist seems such an insult tae Scotland's greatest poet. Sae, Ah wrote the poem based oan that.

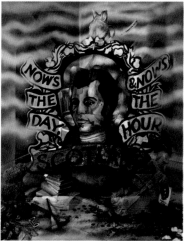

> *The arse oot wir troosers agane,*
> *Syne Darien til the Credit Crunch,*
> *Nae luck aboot the hoose ava!*

An it's a true thing, it seems tae be since time immemorial we've hud wir ain Scottish heroes, but there's ayeweys bin this sort o 'Ah kent his faither' kindae attitude tae Scottish writers an artists bi Westminster governments ...

CALUM: The idea of money, economic control, it's so important to Scotland's history and it's obvious that Burns picked up on that, the 'parcel of rogues'. Scotland's independence was lost due, in part, to the Darien adventure and the subsequent economic ruin. Sometimes it seems we are as a society in a continual spiral of financial disaster, and I think maybe that is also the plight of the artist – the pursuit of money within this spiral to realise the artistic vision – creativity requires cash!

RAB: Art needs patronage an that hus aye bin the wey o things! We're ayeweys 'scartin doun that couch fir the price o a pint', we're ayeweys strugglin tae create oor art in the face o adversity. Burns famously wrote in the 'Lines Written on a Banknote' 'because o thee, I scrimp my glass'. He cuidnae afford

tae buy a roond fir his pals, an then he wrote – wi deliberate irony? – aboot it oan a banknote! An, as you said, Calum, same as wi ane o Leonard Bernstein's themes, the famous set of essays he wrote, 'The Unanswered Question', whaur he talks aboot the story o western civilisation, hou in the past hunner years or sae it's bin 'boom, bust, war – boom, bust, war –boom, bust, war…' an within the last ten years, we've seen wan o the biggest busts ever an, when that happens, aathing gets oot o equilibrium, oot o kilter, an we see it aa roon the world, whaur, because o these kindae huge financial upheavals, there's this equally huge wave o social unrest that can lead tae global catastrophes. An that is hinted at in the picture, aa because o this …

CALUM: The money. Well, if you look at this picture, it is, of course – you don't necessarily see it straight away – but what you see, eventually, is a mechanical horse from the amusement arcades. You see the legend *Rebel* written on the side? I was taken with this idea, this *Rebel* that is only stirred into action when you put money through the slot on the top of it, it reminded me of Burns being constrained by money, or lack of it. You know, his rebellion was kept in check by the fact that he had to feed his family, so he had to be careful about what he said and what he did, and everybody, of course, is controlled that way.

So, we have the Scottish flag in the mist in the background; the idea of nationalism being pushed back, the idea of action and stasis controlled by money.

RAB: Aye, aye, the constant ebb an flow o whit maks hail countries gae up an doon.

CALUM: And here in the picture is the stamp that was the visual and conceptual starting point. These little fragments, these little pieces of detail, of historical detail, as well as physical detail are what come to dominate the whole picture. This 'Twa Plack' stamp, was never an official stamp. It was produced in 1959 by an organisation called the Scottish Secretariat – a radical organisation founded in 1926 – as part of an unsuccessful campaign for a

commemorative stamp marking the bicentennial year of
Burns' birth. Mostly they were just stuck on windows and
lamp posts around Scotland at the time of their printing,
so there aren't that many of them around, so I thought,
well, I'll take that historical footnote and graphic image
and I'll impose it across a big show horse in order to
explore the theme of rebellion, social control and money.

RAB: An when ye luik at the main central image, it's
aamaist kindae lik, it seems tae me, lik a tattoo. Ye cuid
pictur this oan an auld miner or an auld ex army guy or a
sailor's airm. It wis a thing Ah uised tae see a loat workin
in the pits. Constantly. Ah wid hae stairted there aboot 1977, an ye hud young
guys then wha wir in their late teens emulating the aulder guys an gaun an
gettin tattoos – gaun tae Blackpool oan a holiday an comin back wi a tattoo, an
invariably it was Scotia or Scotland the Brave, or a piper!

CALUM: Or the lion rampant.

RAB: Exactly, these kindae things! Ye cuid jist pictur that. Ye've goat Scotland
here, ye cuid jist see that oan somebody's airm, 'Now's The Day And Now's
The Hour', ye can jist see that sort o image, an Ah tak it that that is equally a
deliberate kindae statement, sayin somethin there aboot nationalism or
national pride?

CALUM: Well yea. I thought about tattoos. But look at this
detail here, a snapshot taken from the television one night.
It was a documentary about Polmont Young Offenders
Institution and I noticed that the kids in there had painted
a Burns mural. I thought, it looks a lot like Elvis Presley
but, in fact, it's Burns – 'A Man's a Man for a' That' it says
underneath. So that sense of a glimpse into another world.
The dispossessed. The notion of control and of
desperation for money, and, across here, we've the idea of
*plenty*, Burns and the fruits of the plough.

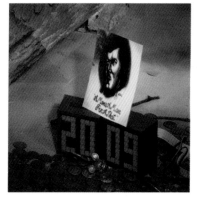

RAB: Aye, the bushels here o barley or corn, the stooks o hay safely gaithert in! If ye like, the wealthy time o year when yer labour hus produced the food an fodder that's gaun tae see ye throu that daurk winter tae come. Sae that they hud a safeguard, an investment against poverty an starvation, because that wis whit they wir aa faced wi.

CALUM: So, I was thinking of that expanse of time, 1759 to 2009 – 2009 being the date I made this picture, expanding the date in the original stamp by 50 years – and the idea of 1759 being a time where objects were crafted; 2009 is the age where the financial industry overshadows all, it seems.

RAB: An money is a kindae magic trick, in a wey. Ye saw that when we hud that huge financial crash in 2008, because that £5, if ye believe in the £5, will buy ye somethin, it works, but when the magic trick disappears an ye dinnae believe in it, suddenly there's nae confidence in the hail thing an it aa jist disappears afore yer een, we dinnae believe in the magic ony mair! An Ah suppose when we wir dealin wi real stuff an we hud a nation wi michty industries that produced things, we were probably in a mair confident sort o position? Ye can believe in a bag o coal, or a bag o tatties!

CALUM: Mammon is the only god – that was my sense of it in 2009, this endless idea of financial ruin, of moving towards a kind of dialectical bias toward the people at the top becomes an overt challenge to people's sense of justice.

RAB: Yea, it's aamaist total corruption that we're facin nou – the Sir Fred Goodwin scandal, ye know, where he loses his knighthood but he is allowed tae keep the millions in his pension. Ah mean, this sort o thing is aamaist taken fir granted nou. If ye are above a certain level, there's nae accountability whitsoevir, leistweys, it seems that wey tae me.

CALUM: I know. They should have given him the Amro Bank as his leaving present.

[laughter]

RAB: Aye, weel, we'll gang oan agane. An this is?

CALUM: This is called *Portrait of Robert Burns (after Archibald Skirving)*. The first Burns picture that I ever made, from 2000, so the oldest picture in the exhibition.

RAB: An this wis inspired b the Skirving chalk drawin o Burns?

CALUM: Yes. When I made this picture, I was at the beginning of a project, an extensive exhibition for the Scottish National Portrait Gallery called *Ossian – Fragments of Ancient Poetry* and this project was intended as a fragmented body of work, part historical, part cultural narrative, which would relate directly to my method of constructing photographic artworks. The historical portrayal of James Macpherson as a forger of Ossianic poetry sparked my curiosity, from the point of view of the idea of all culture being forged in some way. I was also trying to draw comparisons with the status of the *photograph* in the light of new technology and it's effect on how we read images.

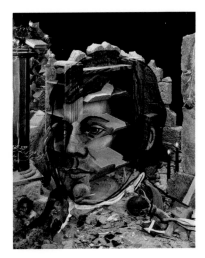

I made a lot of images for this exhibition but, naturally, I came to Burns as a figure I would want to make a portrait of, because I was looking at writers/poets of this time who collected 'fragments' of verse.

So, I created this Ossianic landscape using carved and weathered breeze blocks – a kind of blasted landscape – and I made all the pictures in that series from these basic materials in an endless cycle of re-telling, where the picture changes over time, new characters and stories appear from the ruins of the previous. This one was based on Skirving's iconic drawing as we said. Skirving, I don't think actually met Burns?

RAB: Naw. The Skirving drawin wis created posthumously, sae it is a kindae highly romanticised image o Burns. In a conversation Ah hud wi Sandy Stoddart, the sculptor, he talked aboot the Skirving image o Burns and how it jist floats there, ye know, there is nae neck, there's jist a heid, it just kindae floats there in space, and Sandy said, 'and here we have Burns the God!', he's flawless, he's airbrushed, an that is the image that people like aboot Burns, that is hou they like tae see *their* Burns, ye know, the God-like

perfection o the Skirving image. But, as you say, it's a totally constructed, fabricated Burns.

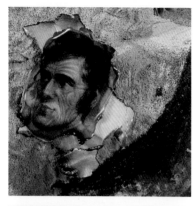

CALUM: That's right, he is often portrayed as this kind of God-like figure. It is a kind of construction. I was looking – within this body of work – at two aspects of Scottish culture, the *invented* and the *native*. In this image I was thinking of Burns as being the 'native'. So, here in this detail he is presented as a kind of Pict, an aboriginal if you like – although in fact I have montaged the facial tattoos from a painting of a Maori chief onto his face.

The invented aspect is represented over here, in this detail, by a *Bossons* figurine – a music hall image of a Scotsman with a bunnet on.

So the idea of the invented and the native, and the play between them – the invention of Scottish culture is alluded to. If you think of Burns as not being averse to a certain amount of self – how would you put it? – self-promotion, self-invention, the idea of the heaven-taught ploughman and the idea that Burns perhaps colluded in his own myth.

RAB: Oh yes, aye, he liked tae play up tae his ain kindae legend, if ye like, an build oan it. Ah mean, at that time, it wis a fashion fir publishers tae gie their poets a by name, ye hud the likes o Peter Duck, an English poet wha wis kent as 'the Wiltshire Thresher', an there wis anither English poet, Mary Collier, she wis known as 'the Peterborough Washerwoman', so Burns becomin 'the Ayrshire Ploughman', this wis creatin a brand.

CALUM: Yes, and Hogg becomes 'the Ettrick Shepherd'.

RAB: Aye, it's creatin an image that the people can relate tae. They cuid relate tae an Ayrshire ploughman an that's hou, in a loat o people, he wid hae stuck in their mind, hou they wid hae thocht o him.

CALUM: So it's a kind of 'brand'!

RAB: Exactly, an the hail Macpherson *Ossian* thing, if ye like, that wis a kind o *The Lord of the Rings* o its time, although at the time Ah think a loat o people wir taen in bi Macpherson an taen it literally as bein a true record o things, when it wisnae! But it wis a great thing that he did – creatin this mystical, magical world.

CALUM: *Ossian*, in a way was a reaction to a pervading sense of loss of identity in Scotland, following on as it did from the perceived submergence of this following the Union and conflicts of the '45. I suppose Macpherson didn't at first appreciate how popular it would be. He reinterprets or he puts down fragments of poems, recollected from his childhood in the Highlands. After a while they are condemned as forgeries by people in England, particularly Samuel Johnson. But you could say, this was a man working with his own culture and his own language and doing what probably every other generation did – or doing what Burns did – he took what fragments remained of old songs in the popular consciousness, and creatively re-interpreted them. So, we have Burns collecting. They all collected – Walter Scott collected poems and songs from The Borders, Hogg, and the *Jacobite Reliques*, but we all know now that they embellished them. The difference is, of course, Burns didn't take any money for it, whereas Macpherson became quite wealthy.

RAB: Aye, an he leeved in London an he wis gien a substantial government pension tae leeve oan, an here wis puir Burns wha created mair than 300 songs, songs that are still sung aa ower the world an recognised by people today frae different nations roond the world an, yet, he received naethin fir that.

CALUM: Is it not true that he refused to take money?

RAB: Yeah, aye, he did refuse, he widnae tak ony payment frae Thomson or Johnson fir the songs... .

CALUM: This whole idea of collecting was very current in Burns' time and, possibly because of Macpherson, the idea of collecting literary fragments of what they saw as a fast-disappearing culture, and holding on to it, recording it for posterity. We often forget the context that these were writings that in the recent past were considered seditious, politically dangerous Jacobite propaganda.

Interestingly an idea that, in contemporary society, you would think of as being the role of photographers – collecting fragments of a vanishing culture. If you think of the great photojournalists from the 1960s onwards, a lot of them were concerned with capturing aspects of a changing world and recording them on film for posterity. Back in the time of Burns and prior to that, Macpherson, I think there's a sense of upheaval, language changing, culture and values rapidly changing.

RAB: Aye, weel, o coorse, James I and VI went doon tae England, an he very much wantit his kingdoms tae hae a common language, that wis yin o his main reasons fir haein the King James Bible prentit in English, it wis a means, in his een, o pullin everywan thegaither an sayin, 'this is the common language you will all now speak', ye know, tae the detriment o his ain country – Scotland – an then that language bein further eroded a century later – 1707, the Union of the Parliaments – till it became verra unfashionable tae speik Scots, an it was beltit oot o us fir generations! It is only in verra, verra raicent times, even nou, that we're beginnin tae say Scots is a valid language. Ye know, it's got a huge literary tradition gaun back a thoosan year or mair, an it's every bit as relevant as English. Sae, there's ayeweys bin these huge debates that hae went oan aboot language.

CALUM: Yes. Well, it's an interesting aspect. What always seemed odd to me about Burns, in terms of a personal experience, growing up in Scotland in the late 1960s and early '70s was, you could recite Burns poetry in the classroom – but you couldn't talk like him, not without some form of sanction!

RAB: That's true, ye still hae the annual Burns competitions an bus loads o weans are taen there tae recite the likes o 'To A Mouse' and 'The Braw Wooer' an aa these ither poems an songs, an yet, if ye speak that braid Scots in certain companies, people still luik doon their nose at ye. Fir instance, a comment Ah heard in a conversation raicently, when Ah was interviewin fir the Scots Language Society up in Buchan in Aberdeenshire, an Gordon M Hay, wha hus jist produced a New Testament in Doric Scots, an yin o the points he made, an this wis sae true, wis that Scots language, whenevir ye hear it, or ye see it bein uised oan television, it's maistly in a comic situation. It's ayeweys trivialised. It's somethin tae be laughed at or sneered at. It's somethin tae be

luiked doon at. It's a source o amusement; but yet, the Scots language can equally dae stuff that is high art an emotionally engagin, an can dael wi serious, serious literature, prose, poetry, TV, theatre... but, fir some reason or ither, that kind o gets pit tae the side an it ayeweys seems appears in some comic thing or ither. Why is that?

CALUM: Well, you see that with the Highlands and the Highlanders and with the post-'45, you see the sense of people ridiculing what they feared. The Highlanders were feared and then ridiculed. I think that's part of a cycle of what happens. You know, history is written by the victor.

RAB: Oh yes, verra much sae. Ah mean, in ither pictures o yours that Ah hae written responses tae, lik yer *Vestiarum Scoticum* triptych of pentins, which deals verra much wi the subject o Culloden and Bonnie Prince Charlie an post-Culloden an hou there wis this kindae cultural genocide gaun oan there, wi the proscription o tartan; fir forty years ye wirnae alloued tae wear the tartan. People hud tae dye their claes wi mud, or plants, or whitever they hud tae disguise the tartan, an sew the kilt thegither atween their legs tae mak it intae a pair o trews. Ye cuidnae wear a kilt. Mind, that's ayweys bin the wey o empires – it still is! Tae subjugate a people, first ye tak awa their language, ye tak awa their national mode o dress, ye mould them intae the image that *you* want them to hae. In itsel, it's a constant battle tae try and retain these key pairts o oor culture.

CALUM: Well, I think for Scotland, what makes it even more complex and interesting is that Scotland's culture is not homogenised, Scotland's culture varies from north to south, from east to west, in really quite distinct ways, and it always has. So Scotland, as a brand, is a very difficult thing. You can't take a man in a kilt standing on a hill and say, that is Scotland, because there's a hundred other ways to represent Scotland and Scottish people. Scotland is a construct really. It's held together despite all these different ways of speaking, these different modes of operating/communicating. It's incredible that Scotland has survived as an idea, as a concept – perhaps not as a country – but really Scotland, we shouldn't really be calling this country Scotland, it should be North Britain, you know. It's an incredible kind of 'creative act'. People like Burns and Scott have become this country, or the idea of Scotland has endured because of that.

RAB: Aye, at the end o the day, it ayeweys comes doon tae an individual. History is made bi individuals, an it's people lik Burns, as ye say, an Scott an MacDiarmid wha are the champions o culture, ye know? If it hudnae bin fir these people, Ah wunner whaur Scottish culture wid be nou?

CALUM: Yes, and without a culture, would we have a country? If we had no culture, if we had no sense of ourselves through language, would we not just be Great Britain plc? So, here it is [points], a shattered Elvis mirror – a kind of shattered, false, self-image.

Here is a mallet, with the word *Worldwide* written on it, which is a reference to the Masons, the worldwide Masonic Order and, of course, Burns was a Mason.

RAB: Weel, through in the exhibition side o the Museum, they've goat oan display Burns' mace that he uised as a Mason.

CALUM: Yes, and I like to make allusions to this aspect of Burns imagery in the works, the secret symbolism, these little objects with Burns in his Masonic gear.

So, on the shelf here there's three books [points], this is the idea of the three 'Rs' – reading, writing and arithmetic – three versions of *Encyclopaedia Britannica*.

RAB: Imphm...

CALUM: So, it's the idea of the self-taught aspect of it, the *autodidact*, as they say!

RAB: Aye, the lad o pairts, an Burns wis a, weel... mibbes he played up tae that as weel, because he did hae quite a sound education fir his times; his faither hired John Murdoch as a tutor an the kids wir schuiled tae a guid level; they hud smatterins o French an Latin, sae mibbes Burns kindae played up tae that lad o pairts image a bit, but he wis obviously a voracious reader an later amassed a guid collection o buiks.

CALUM: Yes. The suggestion of the hearth but, of course, it's a bookshelf, with these books laid out like a reading room – the idea of elevation through education. All presented within this kind of blasted landscape.

RAB: Yeah. An the next picture here is this great characterful face! An you kent this fellah, sae …

CALUM: This is *A Portrait of Colin McLuckie*. When I was a kid, growing up in a village in East Lothian, Colin was a neighbour of my friend, an ex-miner – we used to see him coming out the pub on a Saturday afternoon, and Colin was a great man for reciting Burns poetry. He would come out and recite 'Tam o Shanter' for us with great pathos and great humour, and all the kids would love it! It very much brought the whole idea of Burns as being relevant to everyday life. I saw Colin again recently and I asked if I could do his portrait. He reluctantly agreed – he was very modest – and I took some photographs and talked to him one day. Sadly, Colin died before the picture was finished, so he never saw it. I was thinking about Colin's story and his history – he had been a miner, he'd seen people reciting – professionally, is how he'd put it, people did it for a living, but I'm not sure entirely what he meant by that. Also his mother sang Burns. So, it was interesting to me – the idea of somebody who wasn't a poet as such, but carried on this reciting tradition, and I saw this as an analogy with photography, the idea of recording, repeating, preserving.

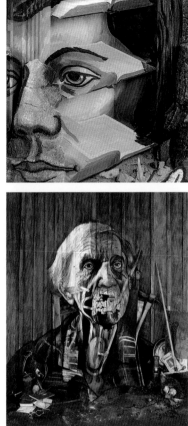

RAB: Tae me, he's jist goat this amazin face, an when Ah wis luikin at writin a poem in response tae this picture, the fact that he hud bin a miner as weel, an keep mind Ah hud eicht years masel in the Ayrshire pits, Ah felt Ah cuid weel relate tae this man's life – the pick here, an the miner's lamp – an thae kindae fowk frae a working-class backgrund, wha wir great reciters o Burns. Evri community hud thaim, an still hus thaim tae this day! Ah ken o plumbers an dental technicians an shepherds wha are great reciters o Burns, an Ah

thocht when Ah wrote the poem fir Colin McLuckie that Ah wid write it in 'Standard Habbie' metre – this is a wee nod tae him as a Burnsian, an as a reciter o Burns' poetry. Wan o the things that struck me aboot it wis that it's aamaist a timeless face. Ah mean, he cuid be a monk or a friar oan Iona; he cuid be a shepherd oot o wan o Scott's novels – he's jist goat this great timeless Scottish face! Sae, it made me think, gaun richt back to kindae Druidic times, whaur the Druids wid pick a likely kindae lad, ye know, that they thocht wid hae hud that uncanny ability tae lairn huge screeds o verse, an sae become the 'Bard' – ye know, become *their* Bard – an train that person up, wi huge memory skills. Sae, in the poem that Ah wrote fir Colin McLuckie;

> Aye, Colin! There wis ne'er lik you,
> Tae speik the leid sae leal an true,
> Their nae dout ye'd thon gift enow,
> Bi Druids divined,
> That they wid train until it grew;
> Bards o their kind.

An in the last stanza o that parteecular poem, there's the deliberate reference tae Hogg's great poem 'Kilmeny', frae his maisterpiece 'The Queen's Wake'. An raicently Ah've bin awardit this James Hogg residency ower in the Borders, sae Hogg's very much in ma mind the noo, an that poem o 'Kilmeny', whaur the eponymous mystical female figure o the poem's title hus bin spirited awa intae fairyland an hus seen magical things an's then cam back briefly tae the rael warld agane – in the poem Hogg's awa somewhaur else tae, some ither realm aamaist. Ah mean, it's as if Colin McLuckie here hus goat this luik o, ye know, 'other-worldliness'; an noo that he's deid an awa, when these voices disappear, folk noo tend tae kindae say, 'Oh, wull there be ither folk that will tak up that torch?', tae be able tae read the great Burns poems as workin cless fowk hae been daein fir generations, an as the Bards did in auncient days, the skill o that great oratory, but yet they dae still seem tae appear… an then the idea o the lamp blawin oot? E'en though this lamp in the picture here is brichtly burnin, mibbe that wid hae bin a better metaphor tae yaise in ma poem, tae hae that lamp mibbes still brichtly burnin rather than haein gaen oot? But it is a worry in the Burns warld the nou, aboot whaur we are gonnae find the people lik Colin McLuckie tae keep recitin the poems an keep thaim alive.

CALUM: Well, there are people, I'm sure, all around the country, like Colin, who recite, I'm sure there will be lots of them – but younger people? I don't know. I would like to think that that will continue. So, here in the picture, these pieces of thread, the red and the white thread and the black and the brown. This idea of the thread of tradition, a strand of time, the microcosm and the macrocosm. Of course this is just powdered paint on the ground, though it could equally be coal dust. So, you get a sense of the universal and the particular, you know, these little microchondria you see through a microscope, that's the idea of these – just the shape of them – and there is a sense of looking beyond with that.

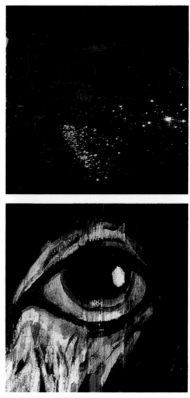

RAB: E'en altho there's elements o the mundane an the prosaic an everyday tools an things lik that, but yet, it's as if there's a kindae timelessness aboot this picture, there really is. There's somethin in his eyes as weel – the huge dilated pupils, it's aamaist as if that's a moon or planet we're luikin at?

CALUM: Colin had an incredibly interesting face for an artist to observe. I also felt very comfortable with him because to me he was a direct link to my own childhood. Though of course I didn't really know him, I felt I did. Initially, the idea had been to do a whole series of reciters throughout Scotland, the problem being, of course, how do you track them down? It was one of these projects that never quite came to fruition.

RAB: Mibbe that's yin we cuid explore in the future because Ah cuid certainly track doon a number o reciters wi real characterful faces. Sae, that micht be somethin fir the future?

CALUM: Well, there's a show!

RAB: There's a show indeed! The big canvas here in the middle – 'The Twa Dogs' – an interestin an challengin picture perhaps?

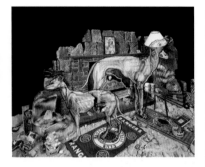

CALUM: Yes, this again is from the Ossian series. I wanted to make an image that would directly refer an Ossianic aspect in Burns poetry. So I picked, of course, 'The Twa Dogs' – a direct reference to the dog in 'The Twa Dogs', or one of the dogs, being *Luath*. So the two dogs – one is Caesar and one is Luath – but I thought what I'll do is, rather than the dog *o' high degree* and the dog *a ploughman's collie*, I thought I'd visit a different duality in Scottish culture – sectarianism. A Rangers dog and a Celtic dog! Because of the nature of these works – I work with objects, I work with things that exist in the world, and although the works look like paintings (and painting is part of the process) – they are not paintings. In fact, they look like collages, but they're not actually collages. They are three-dimensional paintings. The objects within them are all real, manipulated to a certain

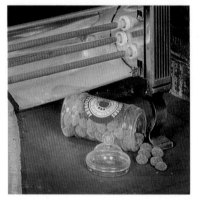

extent, but they're real. So, in this case I went to the Rangers superstore in Sauchiehall Street and bought these various examples of Rangers ephemera – the baby bottle, the orange sweeties, and so on.

Then I went to Parkhead and got an equivalent array of Celtic ephemera, providing the visual material to make the construction. Having been to an Old Firm game, what had struck me was, of course, that it's not like going to most football games in Scotland where they are pretty small affairs really – but if you go to an Old Firm game, what you have are two very, very wealthy – well, at that time – two very, very wealthy *firms* or companies. I thought I'll have a Rangers dog and a Celtic dog, whose heads are made from an Adidas and a Nike training shoe, suggesting a corporate exploitation of historical antagonism.

I realised after I made the Celtic dog with the *Celtic* 'Luath' kind of name on his bowl, and the Rangers dog was going to have a 'Caesar' dog bowl, but then I thought, no, you can't do that because of Billy McNeill, who was nicknamed 'Caesar'. So, I changed it to Kaiser, which is much more Germanic!

RAB: Yea, Ah mean, it's a strikin image. In writin the poem in response tae this picture, an it's somethin that we aa growe up wi in the West o Scotland, there's nae escape frae it, an in a village like New Cumnock, whaur Ah wis born an grew up, there is the usual Rangers-Celtic divide in the village. Ye can drive throu it at certain times an there'll be Union Jacks flyin in places roon the place, sae it's still a thorny issue. Sae, the poem Ah wrote in response tae it – an Ah wis luikin aa round it, ye know, agane there's sae much imagery gaun oan here, but Ah lichted oan the barbed wire doon here, that seemed tae speak o somethin that wis gey unsavoury, jaggy an nasty, aboot wir culture here in the South-West.

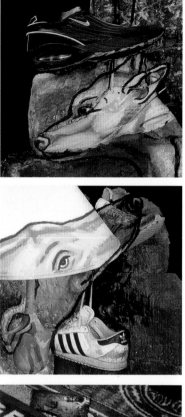

> A gapin mouth grimaces,
> Sectarianism twistit as thon rustit barbed wire;
> Twae fremmit cultures facin different weys.
> 'Ninety meenit bigots' gaither evri Setterday,
> Tae chant their sangs an laithsome slogans.

An Ah think if ye did hae somebody – a foreigner comin frae abroad – walkin throu Glasgow when yin o these mairches wis gaun oan, they widnae really unnerstaun it, the music sounds jist the same. If ye're listenin tae the tunes an the music, the flutes an drums, whaur's the difference? Whaur is the difference here? An they're aa jist usually puir, workin-cless people, ye know, why shuid there be this divide an wha's created it, an in wha's interest is it tae perpetuate this in oor society?

CALUM: Well, if you go through Scottish history, the idea of Protestant-Catholic duality – it's there pretty early, and the idea of Scotland – I mean, Scotland's *name* is said to come from an Irish tribe that came over to Caledonia on the west coast of Scotland from Ireland. Historically, even way back, 15th century or earlier, people in Scotland, historians, were not comfortable with

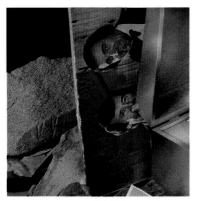

this idea, hence they seize on the mysterious Picts as an idea of an *aboriginal* people. When people think of sectarianism, they think Celtic and Rangers, but that is just a contemporary symptom of an age-old duality. Here is an old record cover – *Scotland's Tartan Lads*. I was at Ibrox watching an Old Firm game – and, at one end, the Celtic fans waving Irish flags and, at the other end, the Rangers fans waving English flags, and I was looking at them and thinking, well, you're all Scottish... so hence the *Tartan Lads*, caught in this endless duality.

RAB: Yea, an ye wid fin thae kindae issues in mony, mony nations, it's no juist peculiar tae Scotland. Alsae, the people wear the scarves an they fly the flags an the majority o thaim dinnae really ken the real history. The Pope at the time supported King William of Orange, and when King William won the Battle of the Boyne, they actually celebrated at the Vatican because the Pope didnae want a Stuart back oan the throne in Britain because that wid hae made an alliance between Britain and France, an he didnae want that strong alliance atween Britain and France that micht hae threatened his power-base, sae he supported – an bank-rolled! – William of Orange, an people dinnae realise that, hou they're aa manipulated bi these powerful figures, they dinnae realise whit's gaun oan – hou they're bein uised tae prop up systems.

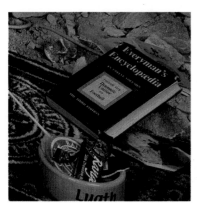

CALUM: This idea of a game of football becoming representative of something bigger, I think it is very vivid for artists and writers. I thought of that when I put this book in the picture – *Everyman's Encyclopaedia, Volume 5, Dramatic Unities to Football*.

RAB: Ah, right.

[*laughter*]

RAB: What's the kindae mountain image here or the ...

CALUM: Well, at Ibrox, they played Tina Turner's 'Simply The Best'. It used to blast out every time a goal was scored by Rangers, and this is a visual pun. Rock – rock music! But then the idea of

scale, the idea of taking something small, and blowing it out of proportion – so the figure in the photo here, the tiny figure beside this giant rock in relation to this monolithic Dansette. So, I am playing with the idea of *proportion*, of the voice being small and large at the same time.

And this dog framed above the mantelpiece here, this Cocker Spaniel represents King Billy *and* the Pope.

RAB: Which brings us oan tae anither very divisive figure.

CALUM: Byron. This was part of another series I did, called *Natural Magic* (after *Letters on Natural Magic Addressed to Sir Walter Scott*, by Sir David Brewster 1832) which was concerned with the science of photography and optics and the phenomena of perception. It also considered the historical antipathy between the Scottish and English scientists (and inventors of stereoscopic devices) Brewster and Wheatstone – which led to a wider meditation on 'rivalries' both visual *and* national. I was thinking of photography both as a science and an art, but within the exhibition I wanted to reflect on the poetic aspect of photography, so I thought I would make an image of Burns – which we see over here – and then I made an image of Byron, here. I wanted to make them as a duality, as a pair, because Burns, of course, spent most of his life in poverty, and Byron came, of course, from a privileged class. I also wanted to make a duality between English and Scottish and play on that. With this picture, if you look, you see a table and a chair, you see a bookstand with some books and, in the picture of Byron, it's the same table and the same chair, so, in essence, the two paintings are different but they are painted of the *same* setting. They reflect back on each other, looking in opposite directions, different vistas but the same viewpoint, two polar opposites in terms of social status. They also have things in common – so we have here a reference to Byron's flight

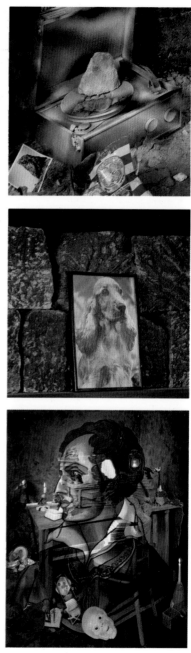

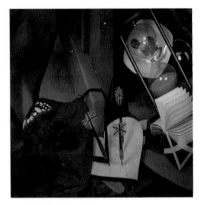

from England in disgrace due to his scandalous activities – *England* flights in the darts! These darts pierce a wooden heart. A suggestion of cruelty and victimhood. A devil's mask...

Byron, of course, is really Scottish, as we all know! But he is assumed here through the symbols in the picture as a quintessentially English poet. And you have the same idea of scandal with Burns as well, where Burns – I think particularly when the first biography was written about him after his death – is portrayed as a deeply flawed character, morally dubious.

RAB: Oh, aye, Currie's biography wis basically a character assassination. Ah think maist scholars wid agree wi that noo. But the damage, the huge damage that was duin then, it tuik aamaist twae centuries tae repair the damage that Currie did wi that biography o Burns, he wis seen in a loat o people's eyes as bein Byron-like, ye know – profligate, an a drinker an a womaniser – he probably liked a drink, he liked women, but Ah dinnae think he wis that outrageous really bi the standard o his times, o course, there are a loat o people in whaes interest it wis tho tae portray him as bein an outrageous figure.

CALUM: Yes, but the sense is, he was of his time, and that was the behaviour pretty much of everyone at that time, in all social strata. Of course, Byron's a different game of soldiers altogether – he really challenged people's sense of morality, although he was still able to stand up in Parliament and take his seat at the top table. So, a very interesting duality between the pair of them but, of course, they are both poets, they are both writers, they are both extremely talented. I wanted to play with that duality, and of course both of them have a connection to Sir Walter Scott. So, here's a wee plate with a bust of Walter Scott, and he appears again in the Burns companion picture as well. Of course, Scott was just a child when he met Burns.

RAB: The poem that wis written in response tae Byron, Ah'd bin haein a conversation wi Nat Edwards, the director o the Museum, an we wir discussin Byron, an Nat hus actually stuid there at the fireplace at Albemarle Street in

Piccadilly, the famous fireplace whaur they burnt Byron's memoirs, an Ah thocht that wis a great kindae thing to play wi, fir this image o Byron here – the real bad boy o British poetry!

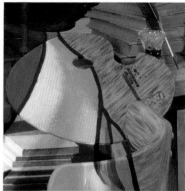

> 50 Albemarle Street, Piccadilly,
> Gaithert roond the famous fireplace;
> John Murray and his son, Thomas Moore, Hobhouse,
> Luttrell, Colonel Doyle and Wilmot Horton,
> Some stare, some luik awa,
> Torn pages faa lik white confetti,
> Post-it notes o a legendary life.

An, agane, there's a loat gaun oan in there; the idea o the hourglass whaur the time has rin oot, the Post-it notes, the Devil's mask, the heart wi the darts stuck in it an the palette, the artist's palette up here, whaur, as Ah say in the poem, 'the paint hus dried oan his dreams'... but a contentious, controversial figure, an e'en the day, an endlessly fascinatin subject tae write aboot!

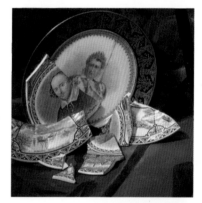

CALUM: Yes, an incredible character. I put Shakespeare in here, of course. Here, on a broken plate in the background is Napoleon, because there is a sense that Byron wants to be the revolutionary, the leader, and he goes off to Greece to fulfil his destiny!

RAB: Aye, there's loats o links, there's loats o links when ye go throu aa the pictures. There's lots o wee links that connect ae picture tae anither – an we hae anither picture, a picture o Napoleon. Napoleon, o coorse, cairriet a copy of Macpherson's *Ossian* wi him oan aa his campaigns, an *Ossian* features in the pictures as weel, sae there's aa these wee links and threids interconnectin the pictures, an the characters, an the imagery, an the story that's bein telt here.

CALUM: Well, the ideas of threads of history have always been very interesting to me. Most artists will read art theory and will maybe read social or political theory in relation to their work. I tend more to look at

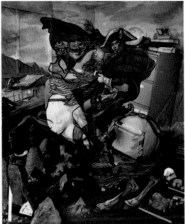

history and try to make works that pick up historical incidents and see how contemporary notions of ourselves are shaped by these little pieces, these little fragments of history that make up the culture that we inhabit, or what seems to be a culture because there's always something beneath the vision we have of a great person or a great poet, or every aspect of our history and our culture. You can just scratch a wee bit of something else that's underneath there.

RAB: An, o coorse, anither great figure here that links a loat o these people is Sir Walter Scott.

CALUM: Yes. Walter Scott knew everybody, of course, amazing relationships. He was a sceptic regarding Macpherson's *Ossian*, but also collected songs and poems from the Borders, and was also, in his way, a great *forger* of Scottish national identity himself. I was always fascinated by the visit of George IV to Scotland and Scott's orchestration of that event, his idea that he would somehow save Scotland from obscurity or from cultural extinction; he would preserve Scotland's self-image, in some form, by restaging this great kind of Highland-based revision of culture and history, which becomes so influential in the subsequent world view of Scotland.

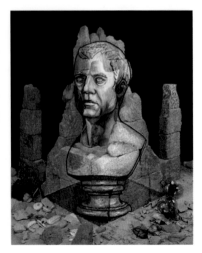

RAB: Burns also kindae hud his douts aboot Macpherson! In 'The Twa Dogs', he talks aboot Luath's name an its origin; Luath wis o coorse Cuchullin's huntin dog in Ossian's *Fingal*. Burns in his poem says,

> *Wha for his friend an' comrade had him,*
> *And in his freaks hud Luath caa'd him,*
> *After some dog in Highlan Sang,*
> *Was made lang syne, lord knows how lang...*

the sly inference bi Burns bein that he kent fou weel that *Ossian* wis nae ancient construct! Onywey Calum, muivin oan...

CALUM: So, I wanted to make Scott as a kind of ambivalent character. There was this idea of both a preserver of culture and somebody who has romanticised, even re-staged Scottish history. So, I presented him in this *blasted* version of the Scott Monument, with a visual illusion – an impossible square, where the bust sits. Down here, Empire biscuits, sweeties and cakes, and a Jimmy hat in the background. So, the idea that he kind of re-invents Scottish identity, but then, on the other hand, he preserves it.

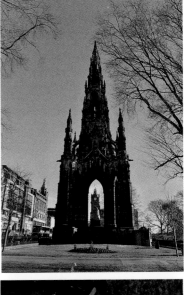

RAB: Yea, he kindae manipulates it tae his ain ends. Agane, a man wha is sort o creatin his ain version o Scottish history, single-handedly. The poem that Ah wrote fir Scott, an Ah decided, because he wis such a kindae traditionalist, Ah wid write a formal sonnet fir Walter Scott, an readin up oan Scott, he wis a real champion fir the Scottish cause – he focht tae preserve Scottish laws and legislation, an oor culture. Scotland hus its ain unique legislation an law, an this wis bein eroded at that time, an he focht against that an it upset him emotionally, it upset him greatly; the government o the time tryin tae tinker wi Scottish legislation. He wrote a famous series o letters tae the newspapers unner the *nom de plume* Malachi Malagrowther aboot the plans – agane English plans – tae dae awa wi Scottish banknotes, an he virtually single-handedly overturned that. Sae, Ah jist thocht Ah'd dae a sonnet talkin aboot Scott's single-handed battle to preserve Scottish culture an oor ain currency the important pairt he played in that continuin struggle.

> Losh! when they tried tae rob us o oor banknotes,
> Malachi Malagrowther spake his mind,
> An seen tae't thon ill-hairtit act wis tyned,

An interestin that his novels richt nou are enjoyin a renaissance, bein rewritten fir a new generation. David Purdie, the great Burns scholar, hus

duin a version o *Ivanhoe* that's bin abridged fir a mair modern readership, an he's juist aboot tae launch *Heart of Midlothian* in this abridged shortened form, ye know, takkin oot aa the kindae borin lang-winded sections and leavin aa the action and the central story. Sae, Scott hus still goat a great tale tae tell an, lik ony great artist frae ony generation, be it Byron, be it Burns, ye know, that story, Ah think, is aye gaun tae hae a relevance in Scottish society an in global literature.

CALUM: Reputations under constant re-evaluation. You see this with Burns being reborn for every new generation, and we may be in this process for Scott, as we see Abbotsford being re-opened. A whole new idea of Scott could emerge as they pull all kinds of curiosities and objects out of the backs of cupboards. So, maybe the whole story of Scott hasn't yet been told. I think that is kind of interesting, this fractured mirror, from which we look back at our own culture and our own historical figures – we keep seeing them differently.

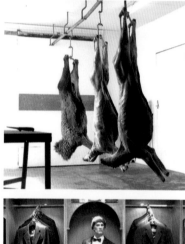

RAB: Weel, it's bin an absolutely fascinatin day here at the Robert Burns Birthplace Museum, Ah've really enjoyed oor braw conversation, jist bletherin an haein a bit craic aboot this tremendous set o pictures, *Burnsiana*. Ah'm shair there's much mair we cuid hae said, Calum, an there are certainly pictures that wull be in the buik that arenae oan display here the day, there's a loat mair left tae be said aboot the *Burnsiana* exhibition.

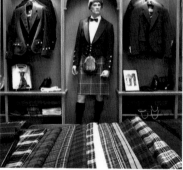

CALUM: Well, there are other works in this exhibition we could talk about for a fair wee while. *Blind Ossian* from the 'Fragments' series we talked about before. Or *Camera Lucida*, a series of pictures which work with the metaphor of light and dark, referring to Tennyson's 'In Memoriam' but equally inspired by Burns' 'Man Was Made to Mourn' and 'John Anderson My Jo'. Other works you have written responses to include *Vestiarium Scoticum*, a digital

photomontage inspired by a visit to the Culloden Battlefield site, a venison processing factory in Sutherland and a kilt shop in Edinburgh. We could be here all day!

The idea for this whole project was to start with Burns, and somehow end up with Burns but, in the process, contemplate subjects such as politics, mortality, tartanry, all kind of aspects of contemporary culture, ideas related to sectarianism, portraiture, and to look at characters from the time of Burns, to hold a mirror to aspects of contemporary society. That's why calling the whole project *Burnsiana* seemed an apt thing to do because it's of Burns and from Burns, but it's a whole world of reference.

## Burnsiana

*Prologue*

Strip back stratum and substratum,
layer upon layer upon layer;
Until we get to the heart of it.
The overlap and overlay,
copings, courses and coverings,
microscopic microns of lamination,
the seams, the sheets, the slabs,
till all we have is the story.
Dissect the meta-data,
Disentangle the double-helix,
Cause sub-atomic particles
To collide –
What are we looking at?

## Burns Country

Mauchline ware an kitsch,
Knick-knackets, geegaws an ferlies,
Thon's yer kintra nou.
At the Holy Fair the stalls aa groan,
Ladent doun wi trashtrie,
Whiles hairy-arsed bikers,
An douce WRI matrons,
Aa vie tae wheedle oor placks frae us.
Poosie Nancies Inn's stowed tae the
    gunnels,
The boy in the snug strums his
    guitar,
'Sing it... sing it fir us nou!'
(he aye firgets the wirds when he's
    fou!)
*The Catrine woods were yellow seen...*
Benignly ye gaze oot ower aathing,
Takkin it aa in.
Yer grasshopper mind awa
    elsewhaur,
The fields, the wuids, the trees,
Alive wi birdsang, houlets an doo's,
Sparras an birds o paradise (why no?)
The fabled halcyon,
biggin its floatin nest oan the sea,
sowtherin aa tae calmness.
A braith o wuin souchs throu the
    birks,
*'An ilka bird sang o' its love,*
*and fondly sae did I o' mine.'*
The rose in bloom,
poppies in the hairst-time field,

daunderin wi yer latest limmer,
in a waukin dwam o thocht.
The raucous crood intrudes tae rax ye
    back,
The vennel thrang wi breengin
    bodies,
The fremmit souns o Rock n' Roll;
'Gie's wan bi the King!'
Coila wove a croun fir you,
Holly leaves an berries intertwined,
'C'mon, gie's wan bi the King!'
An in the snug aabody sings.

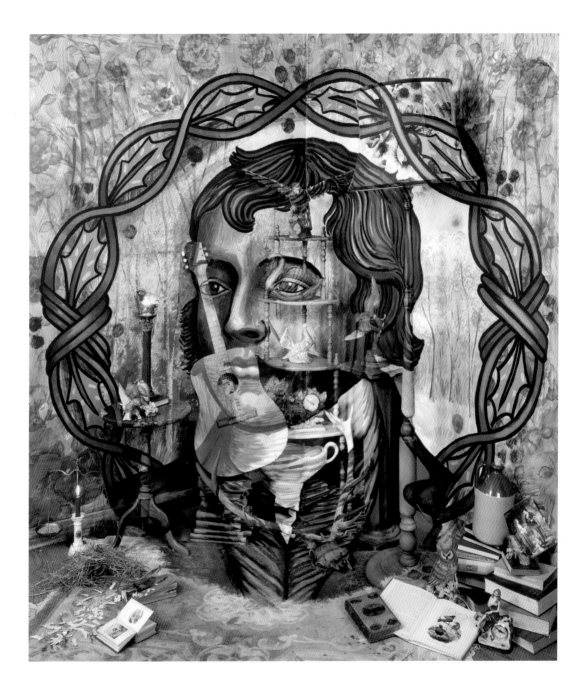

CALUM COLVIN AND RAB WILSON

## Twa Plack

The arse oot wir troosers agane,
Syne Darien til the Credit Crunch,
Nae luck aboot the hoose ava!
Fred shredded,
Broon's piggy bank tint,
Austerity measures,
An, ceptin fir the bankers,
Aabody's skint!
Scartin doun the couch
Fir the price o a pint.
Naethin new here tho –
'59, no a vintage year,
Despite Super-Mac's enunciation;
'Ye've nevir hud it sae guid!'
A stamp tae commemorate Burns!?
Awa an bile yer heid!
Gin we hud twa placks
Tae rub thegaither
We'd shairly fin some better ploy
Tae spend oor siller oan.
Tho gif ye've 40 Kopeks,
In Russia or Romania,
Thair's stamps aplenty
Commemoratin oor Bard.
Thon man wis richt enow;
'A prophet's ne'er honoured,
In his ain kintra.'

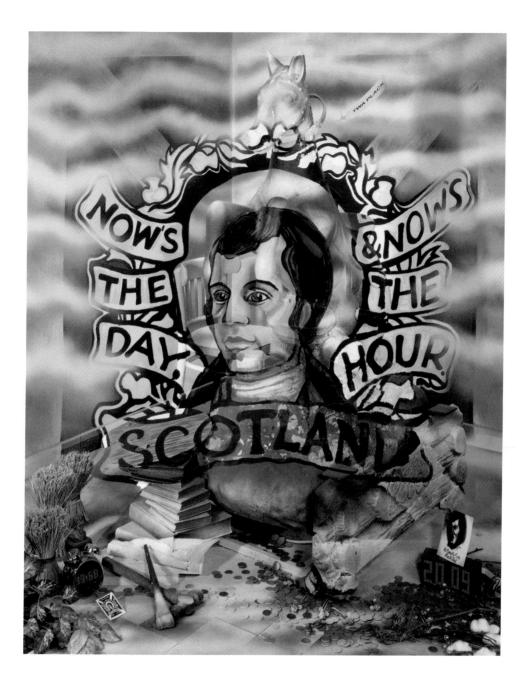

CALUM COLVIN AND RAB WILSON

## Portrait of Colin McLuckie

The Bard's wirds hae aa turnt til mools,
The canty sang's nou dowf an dool,
Time's redd awa yer picks an shuils,
Nae mair ye'll sing,
Whiles young anes mouth the wirds o fuils –
They're deif an blin!

You, as a boy at pickin tables,
Else, reddin-oot at Main-Gate stables,
Heard giants speak wha wir weel able,
Tae tell Burns' lays,
The thocht cam tae ye, you wid ettle,
Tae dae the same.

Sae frae yer piece-bag ilka shift,
The buiks ye'd prie an ne'er missed,
A chaunce tae set yer hairns adrift,
In poetry,
Whiles thae 'auld heids' wid keep ye richt,
Wi whit tae dae.

An later in the gairden shed,
Or setten oot yer onion beds,
The wirds ye'd gang ower in yer head,
Syne they wir richt,
Till then ye swooped lik some young gled,
In its first flicht!

Aye, Colin! There wis ne'er lik you,
Tae speik the leid sae leal an true,
Their nae dout ye'd thon gift enow,
Bi Druids divined,
That they wid train until it grew;
Bards o their kind.

Thon luik ye hae, as gif ye'd seen,
That laund whaur aince Kimeny'd been,
A warld lang-tint in some auld dream,
Ye tried tae tell,
The laump's gaen oot, aa's left auld frien's
A brucken spell.

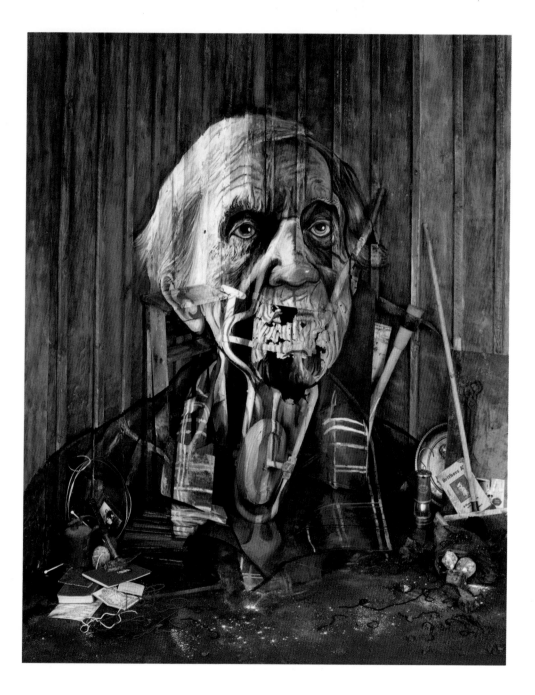

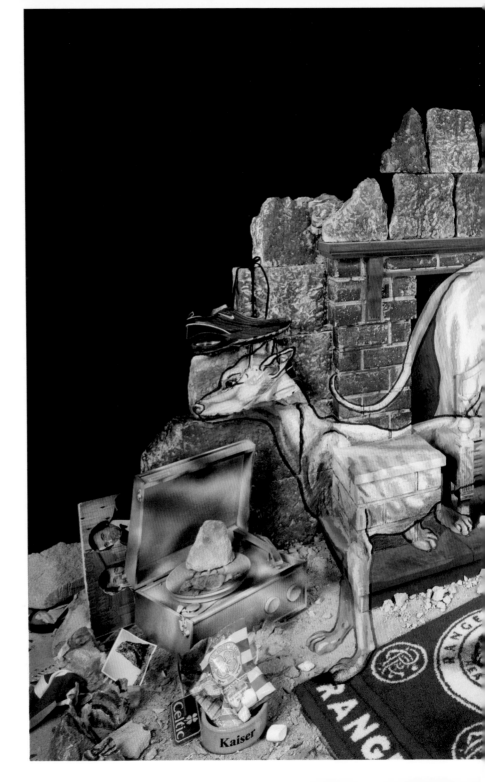

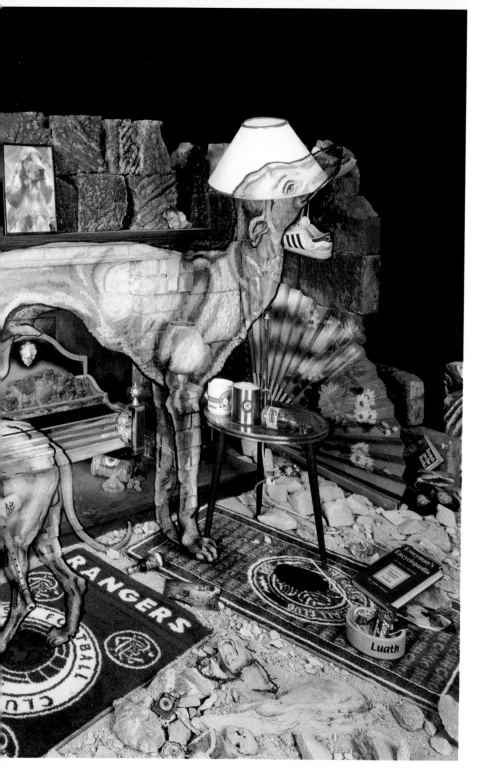

## The Twa Dugs

A gapin mouth grimaces,
Sectarianism twistit as thon rustit barbed wire;
Twae fremmit cultures facin different weys.
'Ninety meenit bigots' gaither evri Setterday,
Tae chant their sangs an laithsome slogans.
An yet gin corporations cuid distil
Sic blind adherence,
Brand loyalty,
D'ye think they widnae?
Airmies o Adidas adherents,
Nummerless nations o Nike neds,
Aa tryin tae be individuals –
Aa endin up identical;
'Terms and conditions apply'.
The Tartan Lads provide oor soundtrack;
'Aye Ready' or 'Danny Boy',
Mairch ahint a flute baund, blue or green,
Tae me the tunes soun aa the same.

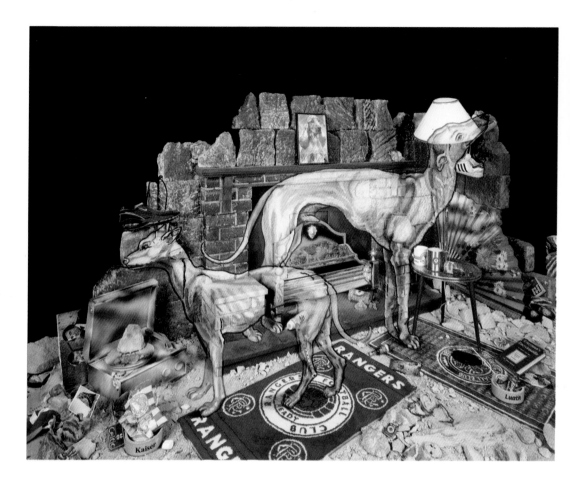

## Portrait of Robert Burns after Archibald Skirving

A queer amalgam
O Rousseau's 'noble savage'
An Ossian's weird dreamscape –
A wild creature tamed bi education.
Heid stapt fou o buikish lear;
*Masson's Collection, Fisher's English Grammar,*
*Bible an New Testament,*
*The History of Sir William Wallace,*
*The Life of Hannibal...*
Nae 'heaven-taught ploughman' here!
Thaim wha bocht McKenzie's nonsense
Wir aiblins aa taen in?
Yer faither kent the warth o Murdoch's fee,
An sowed the seeds tae reap a michty hairst.
An yet cam nicht ye'd steal around the fire,
Tae sit, een stelled, tae hear auld Betty's tales;
'Thae 'Three R's' are geyan weel –
But magick maun be conjured fir oor spell!'
Skirving, tho he nevir met ye,
Portrayed ye as a God.

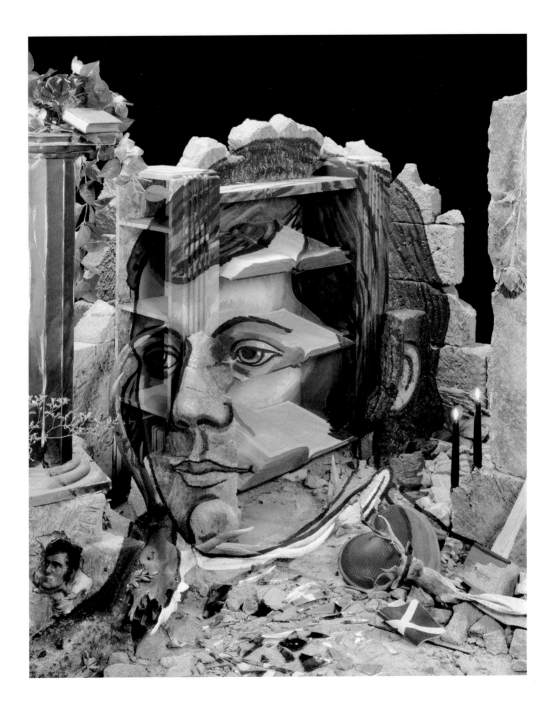

## Blue Burns

This bears the hallmark of the
'King of Kitsch'.
Tretchikoff, who knew a thing or two,
About piling them high,
And selling them cheap.
I remember the lurid '70s wallpaper
And your ubiquitous 'Chinese Girl',
That hung among the chip-pan odour,
And Saturday's teatime football results.
So fitting you and Burns should finally meet.
Would you approve?
Or think the whole thing 'tongue in cheek'?
You're made for each other!
That quote you made about Van Gogh –
Priceless!
Wayne Hemingway likens you to Warhol!
(And Uri Geller worships at your feet!)
What's not to like?
And the auctioneer has a sweet-spot –
Between £500K and a million.

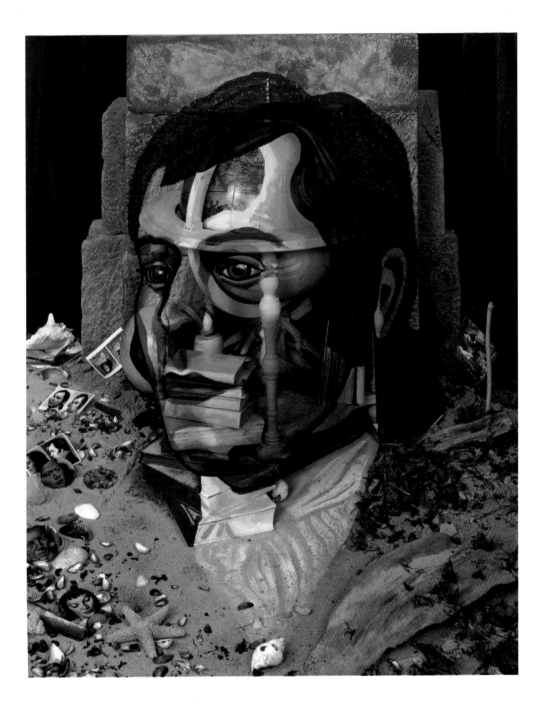

CALUM COLVIN AND RAB WILSON

## Negative Sublime I

Currie's hatchet joab fair dinged ye doun,
Dismissed a dissipated drunken rake;
But aiblins thon said mair aboot him,
Than it did aboot yersel.
Hou lang hus it taen
Tae rid ye o this slander?
Belatedly yer friens aa gaithert roun;
Clark, Dalziel, Mitchell, Jessy Lewars,
Anna Montague an Maria Riddell.
But the damage wis duin.
Twa hunner year sinsyne the wark gaes oan,
Restorin Robin's ravaged reputation,
Whiles e'en fate steps in tae lend a haund,
The letter fand bi David Brown,
Testimony o a deein man :
'I'm only 36. Ten of which only
I have been in the world,
And in that time, all I should say
My good Sir,
I have not been idle.'

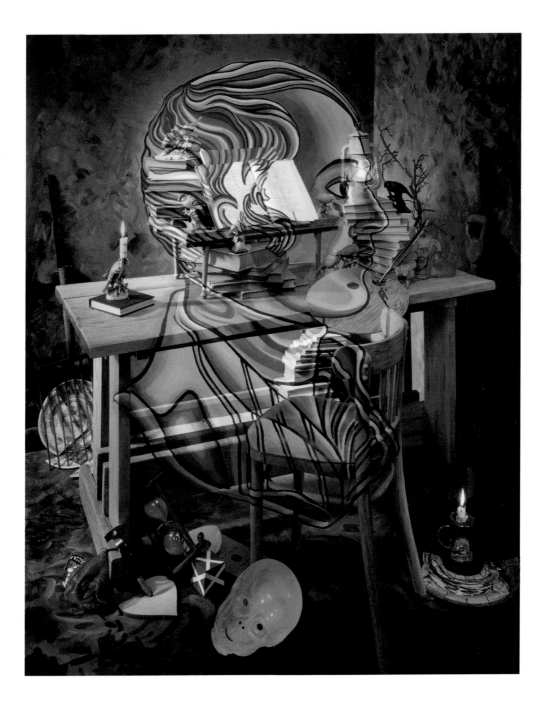

CALUM COLVIN AND RAB WILSON

## Blind Ossian

Deep down the bucket drops
Into the well.
In light its silver cargo
Slops and fills the cup.
The blind bard drinks his fill.
On his face he feels the wind,
The rain, the welcome warmth of sun.
The elders give him things;
The feather from the Eagle's nest,
Six pointed antler from a mighty stag,
Seaweed, which he holds up to his ear,
A brightly burning lamp of precious oil.
So now he sees.
He sees the things the sighted cannot see.
He sees the field of battle from on high,
The heave and push of men,
The blood-stained earth,
The prow that juts onto the shingled shore,
And smells the smoke of endless funeral pyres.
They wonder at his tears,
And why, led to the cliff,
He stands for hours staring out at the sea.

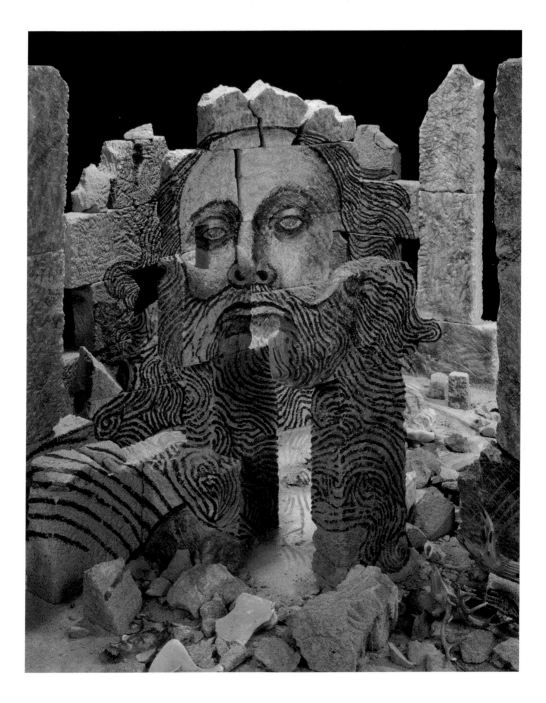

## Sir Walter Scott

They dinnae ken ye really Wattie dae they?
But ahint thae suits o armour, auld aik caskets,
'See You Jimmy' hats an Empire Biscuits,
Yer hairt an mind cared anely fir yer kintra.
Lockhart in his 'Life' describes the scene,
Whan ye wir muived tae tears oan the plainstanes;
'Nocht that maks Scotland Scotland shall remain!'
Syne stelled agin the Mound ye hid yer een.
Losh! when they tried tae rob us o oor banknotes,
Malachi Malagrowther spake his mind,
An seen tae't thon ill-hairtit Act wis tyned,
(E'en tenners nou still kythe the face o Scott!).
Oor proto-nationalism hud began –
Scotland owed ne'er sae much tae jist wan man.

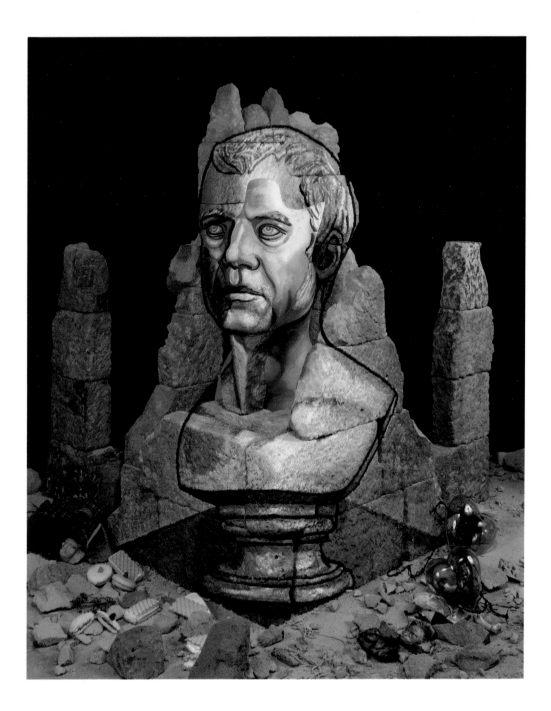

CALUM COLVIN AND RAB WILSON

## Negative Sublime II (or 'Portrait of Lord Byron')

50 Albemarle Street, Piccadilly,
Gaithert roond the famous fireplace;
John Murray and his son, Thomas Moore, Hobhouse,
Luttrell , Colonel Doyle an Wilmot Horton.
Some stare, some luik awa,
Torn pages faa lik white confetti,
Post-it notes o a legendary life.
A De'il's mask o reek an flames,
Yer licentious litany lowps up the lum!
Incestuous romps wi Augusta Leigh,
Caroline Lamb gane gyte an anorexic,
An lea'n us the legend she bestowed;
'Mad, bad, and dangerous to know!'
Threesomes wi the Count,
Threesomes wi the Contessa,
Buggering boat-boys in yer Gondola,
Servants sodomised, DP'd an abused,
Seduced bi your cunnilingua-franca,
Bastart weans produced, abandoned.
Nou the saund's rin oot – the gless is empty,
The dairts o time hae driven throu yer hairt,
Skulls grin – 'timor mortis conturbat me',
The paint's dried oan the palette o yer dreams.

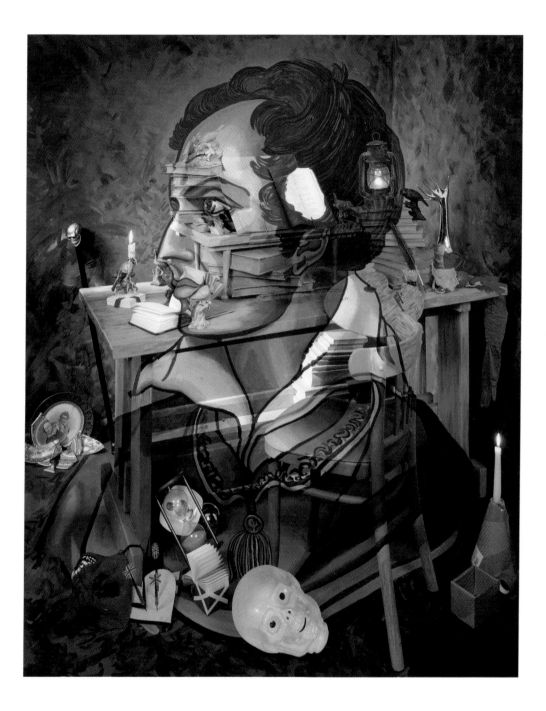

## Napoleon

'I sit in my grief!
I wait for morning in my tears!
Rear the tomb, ye friends of the dead!
Close it not till Colma come.
My life flies away like a dream!
why should I stay behind? *' –
Napoleon said the lines were the song of Selma.
Arnault disagreed;
The poem of Berathon, he said.
A *louis* was wagered;
Napoleon lost.
He didn't pay up.
Such are the ways of 'great men'!
But high on the St Bernard's Pass,
The little book you clasped,
Close to your heart,
Fuelled your visions
Of worlds left to conquer.

*Lines from Macpherson's *Ossian*
– quoted in Goethe's *The Sorrows of Young Werther*.

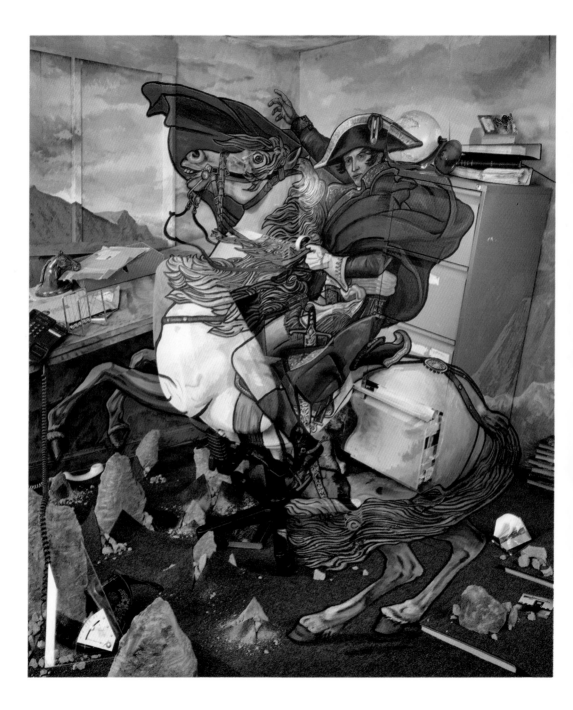

CALUM COLVIN AND RAB WILSON

## Camera Lucida

We're not quite sure of what we are seeing.
You think you see the Dürer figure,
Eyes closed in profound contemplation,
A melancholic magick trick –
Where time has run out.
Before your very eyes he disappears.
Unravelling like those balls
Of abandoned yarn;
Is the cup half full?
Or half empty?
Perhaps we are intruding on a dream,
Or a dream is intruding on us.
Tennyson's 'In Memoriam' on the floor,
Lies adjacent to a tapestry,
Carelessly unframed.
Whose the startled enigmatic face?
The *Young Hare* crouches calmly in the corner.
The picture journeys on into its darkness.

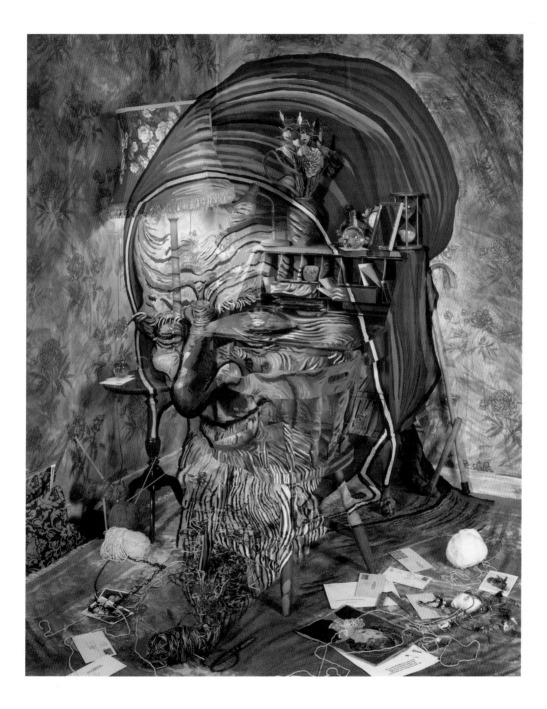

CALUM COLVIN AND RAB WILSON

CALUM COLVIN AND RAB WILSON

73

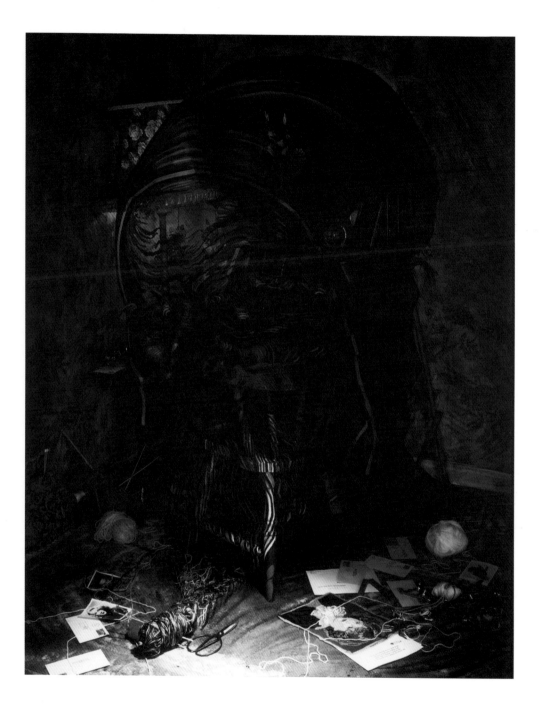

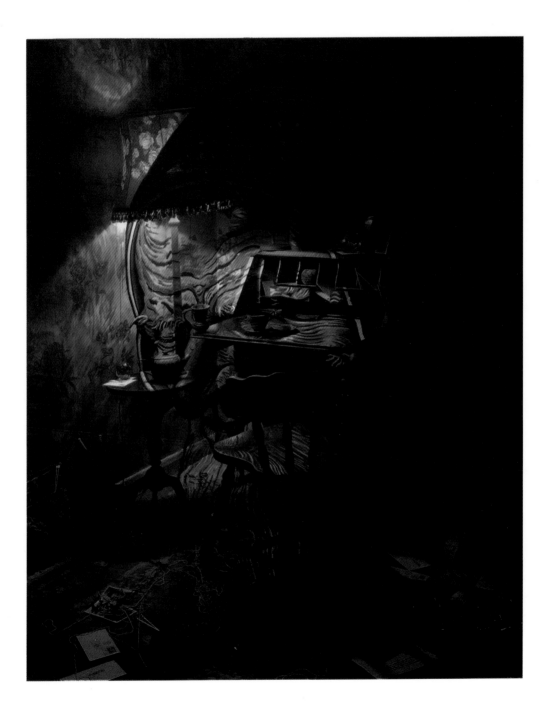

## Vestiarum Scoticum I

Nothing here is what it seems;
The Sobieski Stuart brothers
Pulled literally the wool over people's eyes.
Conmen, who claimed descent
From the 'Bonnie Prince',
Pedalling their bolts of gaudy cloth.
One hundred years before,
The sleet drove thick on Drummossie Moor,
Acrid smoke made clansmen choke,
As they waited, and waited,
For the order 'Claymore!' –
Then finally they broke;
Mackintoshes of Clan Chattan,
MacGillivrays and MacBeans,
Their battlecries;
'Loch Moy!' and 'Dunmaglass!'
Charging into history,
Cut down by volley and grapeshot,
Till at last the crimson tide ebbed,
And those that could slunk home.
By nightfall beggars
Had stripped the bodies naked.

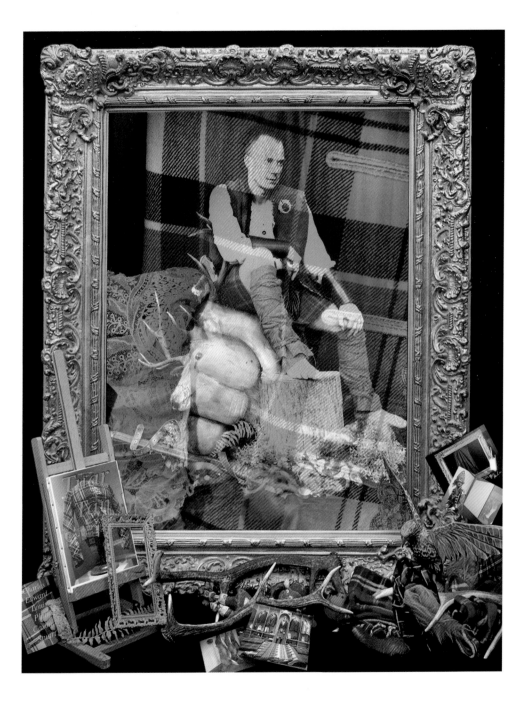

CALUM COLVIN AND RAB WILSON

## Vestiarum Scoticum II

Cumberland, to his shame, announced
'No Quarter!'
Though the clans no doubt
Would have done the same.
For days the Royals and Cholmondeley's
Scoured the sodden moor,
Salvaging loot and souvenirs;
Dags and dirks and daggers,
Claymore, targe, Lochaber axe,
And bayoneting the wounded.
Bespattered with mud and blood,
The torn and tattered tartan plaids
The beggars hadn't taken,
They flung in tarns or left to rot.
And when all the atrocities
And executions were over
A law was passed that made them swear;
'as I shall answer to God
At the great day of judgement,
To never use tartan, plaid,
Or any part of Highland garb...'

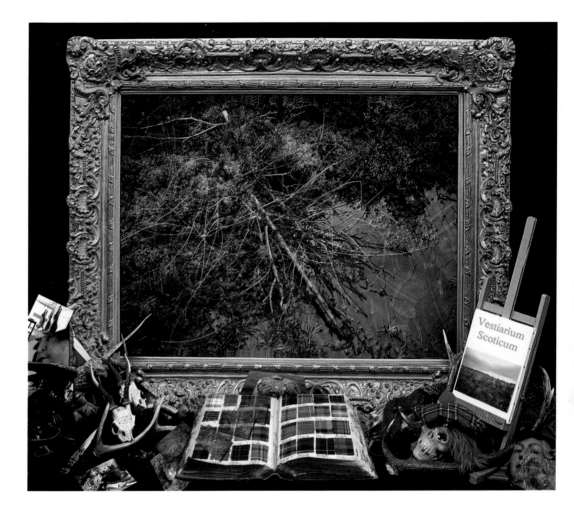

## Vestiarum Scoticum III

There's no doubt Burns would have noted,
In 1782,
The repeal of the hated proscription act.
Though whether Charles Edward Stuart,
Claret sodden and syphilitic in Rome,
Paid it any heed, who knows?
Within a decade of Walter Scott's death,
Tartans appeared, some said were fake –
The 'Stuart' brothers were on the make!
Claiming genuine provenance,
'ane ancient manuscript'
Owned once by the Bishop of Ross –
But were these tartans the real McCoy!?
Something in their story caught the zeitgeist,
And mills and looms in Scotland boomed,
Swung into overdrive;
Weaving a history that never was.
In the old Culloden visitors centre,
Shop window dummies wore the garb,
That once would have meant transportation.
While gentlemen tailors on The Royal Mile,
Keenly show you lurid setts and swatches,
(Will that be cash or credit card?)
To deck you out like Harry Lauder,
As the ghost of Gillies MacBean looks on.

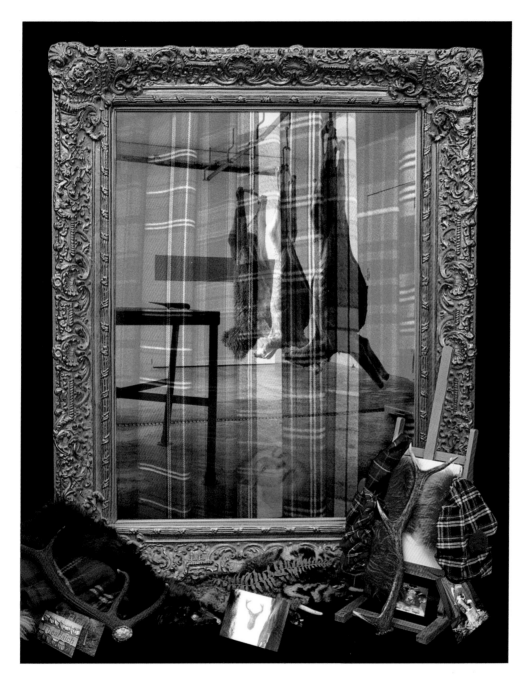

## Pictland

Aefauld, auncient, aamaist, able,
Bauchle, ballant, baw-bee, birstle,
Cantrip, crabbit, clockin, clorach,
Dirdum, dwaiblie, daicent, didnae,
Ettle, ersit, eident, eekfow,
Fettle, fankle, filschach, fouterie,
Glaikit, glumshie, gangrel, gallus,
Hamit, haivers, hirple, hushoch,
Innin, ilka, indyte, island,
Jing-bang, joco, jundie, jouker,
Keelie, kebbock, kingrik, kittle,
Lowrie, lowpin, libbit, larach,
Machair, mowdie, moochin, mingin,
Nebbie, needfu, nippy, niffnaff,
Oanshach, ongaun, oorie, oxter,
Puirtith, puggled, proodfu, porritch,
Queeple, querious, quiscous, quinkill,
Raivel, rammage, roukit, ram-stam,
Smeekit, stoatin, steamin, stocious,
Taigled, towtie, toustie, tentie,
Unleeze, unhool, unthurl, uhuh,
Vauntie, vexsome, vizzy, voky,
Wally, wamfler, waukrife, whummle,
Yalloch, yammer, yatter, yoller,
Zulu, zickety, Zetland; z'attit?

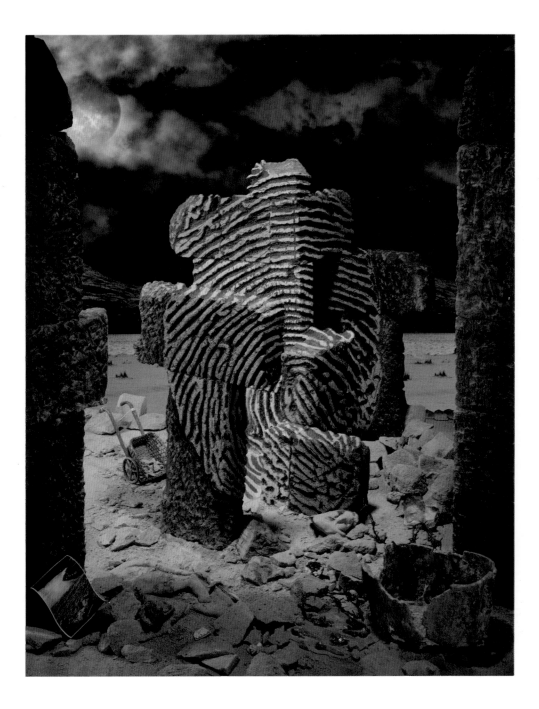

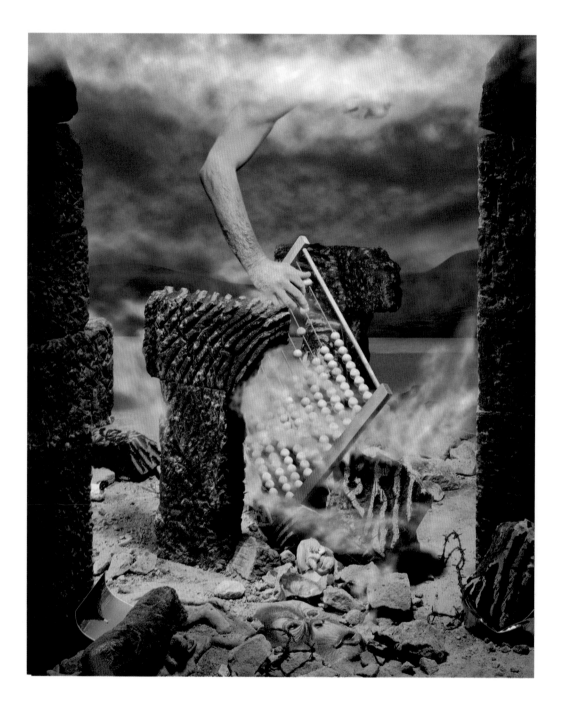

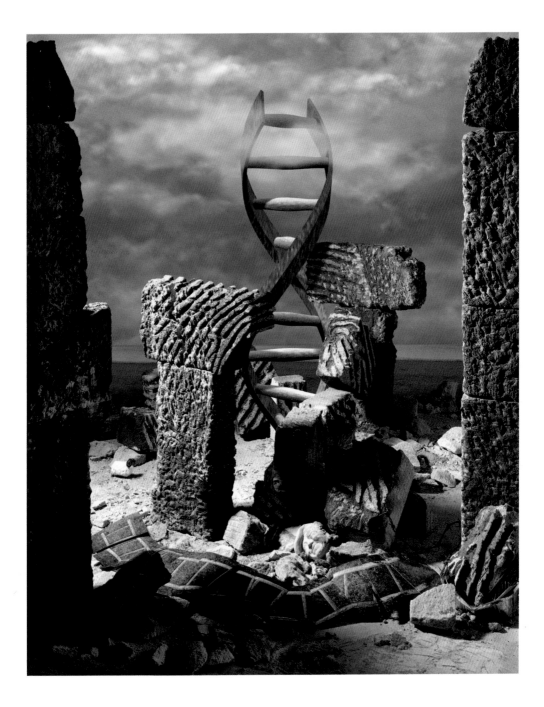

CALUM COLVIN AND RAB WILSON                                            87

## Burnsiana

*Epilogue*

Scroll back from the cosmos,
To inner space.
The mind's micro-structure;
Nanoscientists mind-mapping
The brain's hundred billion neurons,
Its thousand trillion connections,
Processing 0.1 quadrillion thoughts per second.
Vastly more sophisticated
Than any computer.
What causes that leap
Across the synapse?
The spark between Creator and Man?
That lets the poet contemplate the rose –
And move the human heart.

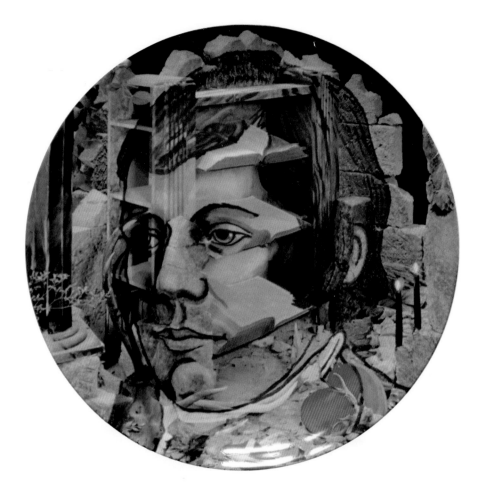

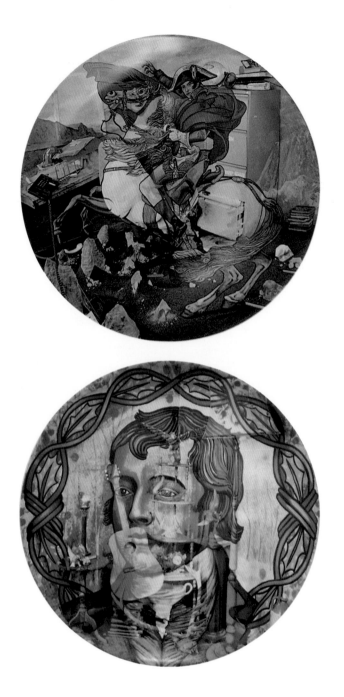

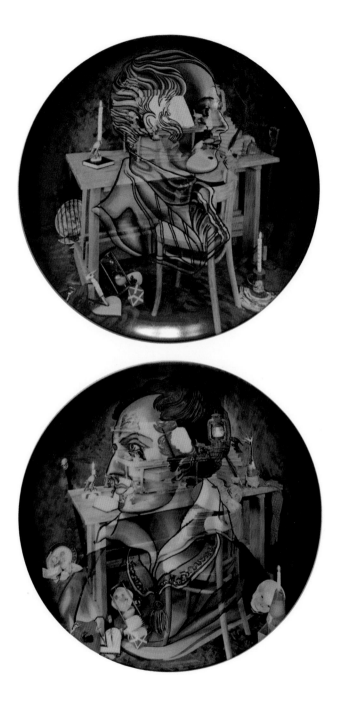

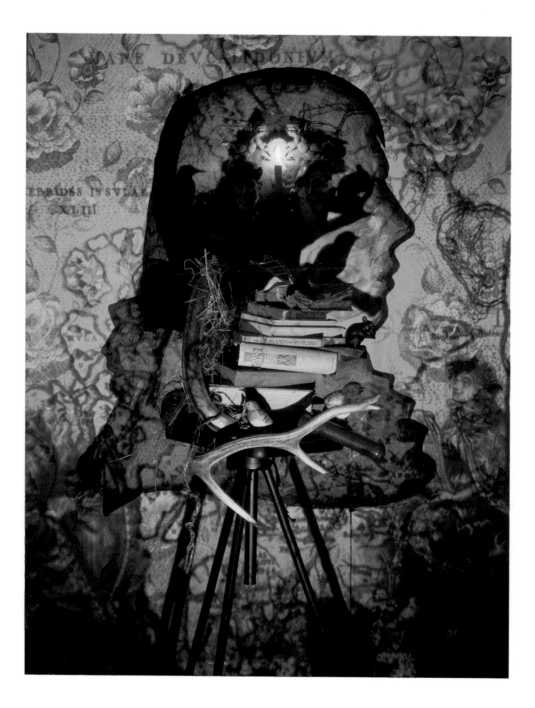

## Title of Works

p47 'Burns Country' 2012
Digital print on canvas
120 x 104 cms · Edition 10

p49 'Twa Plack' 2009
Digital print on canvas
151 x 122 cms · Edition 10

p51 'Portrait of Colin McLuckie' 2011
Digital print on canvas
102 x 80 cms · Edition 10

pp 52–53, 55 'Twa Dogs' (from the
series 'Ossian Fragments of Ancient
Poetry') 2001,
Digital print on canvas
104 x 130 cms · Edition 10

p57 'Portrait of Robert Burns'
(from the series 'Ossian Fragments
of Ancient Poetry') 2001
Digital print on canvas
130 x 104 cms · Edition 10

p59 'Blue Burns' 2013
Digital photographic print
78 x 63 cms · Edition 10

p61 'Negative Sublime I' (or 'Portrait
of Robert Burns', from the series
'Natural Magic') 2001
Digital photographic print
104 x 84 cms · Edition 10

p63 'Blind Ossian I' (from the series
'Ossian Fragments of Ancient
Poetry') 2001
Digital print on canvas
130 x 104 cms · Edition 10

p65 'Portrait of Sir Walter Scott'
2001
Digital print on canvas
130 x 104 cms · Edition 10

p67 'Negative Sublime II'
(or 'Portrait of Lord Byron', from the
series 'Natural Magic') 2001
Digital photographic print
104 x 84 cms · Edition 10

p69 'Bonaparte Crossing the
St Bernard Pass (after David)' 2005
Digital print on canvas
122 x 104 cms

p71 'Camera Lucida II' 2011
Digital photographic print
78 x 63 cms · Edition 10

p72 'Camera Lucida IV' 2011
Digital photographic print
78 x 63 cms · Edition 10

p73 'Camera Lucida V' 2011
Digital photographic print
78 x 63 cms · Edition 10

## Ceramic Works

p74 'Camera Lucida VI' 2011
Digital photographic print
78 x 63 cms · Edition 10

p75 'Camera Lucida VII' 2011
Digital photographic print
78 x 63 cms · Edition 10

p76 'Camera Lucida X' 2011
Digital photographic print
78 x 63 cms · Edition 10

p79 'Vestiarium Scoticum I' 2005
Digital print on canvas
51 x 38 cms · Edition 10

p81 'Vestiarium Scoticum II' 2005
Digital print on canvas
51 x 58 cms · Edition 10

p83 'Vestiarium Scoticum III' 2005
Digital print on canvas
51 x 38 cms · Edition 10

p85 'Cruthni I' 2001
Digital print on canvas
130 x 104 cms · Edition 10

p86 'Cruthni II' 2001
Digital print on canvas
130 x 104 cms · Edition 10

p87 'Cruthni III' 2001
Digital print on canvas
130 x 104 cms · Edition 10

p89 'Portrait of Robert Burns
(after Skirving)' 2012
274mm wide x 25mm deep
Edition 25

p90 'Burns Country' 2012
274mm wide x 25mm deep
Edition 25

p90 'Bonaparte Crossing the St
Bernard Pass' 2012
274mm wide x 25mm deep
Edition 25

p91 'Negative Sublime I' 2012
274mm wide x 25mm deep
Edition 25

p91 'Negative Sublime II' 2013
274mm wide x 25mm deep
Edition 25

## **Luath** Press Limited

*committed to publishing well written books worth reading*

LUATH PRESS takes its name from Robert Burns, whose little collie Luath (*Gael.,* swift or nimble) tripped up Jean Armour at a wedding and gave him the chance to speak to the woman who was to be his wife and the abiding love of his life. Burns called one of 'The Twa Dogs' Luath after Cuchullin's hunting dog in Ossian's *Fingal*. Luath Press was established in 1981 in the heart of Burns country, and now resides a few steps up the road from Burns' first lodgings on Edinburgh's Royal Mile.

Luath offers you distinctive writing with a hint of unexpected pleasures.

Most bookshops in the UK, the US, Canada, Australia, New Zealand and parts of Europe either carry our books in stock or can order them for you. To order direct from us, please send a £sterling cheque, postal order, international money order or your credit card details (number, address of cardholder and expiry date) to us at the address below. Please add post and packing as follows: UK – £1.00 per delivery address; overseas surface mail – £2.50 per delivery address; overseas airmail – £3.50 for the first book to each delivery address, plus £1.00 for each additional book by airmail to the same address. If your order is a gift, we will happily enclose your card or message at no extra charge.

**Luath** Press Limited
543/2 Castlehill
The Royal Mile
Edinburgh EH1 2ND
Scotland
Telephone: 0131 225 4326 (24 hours)
Fax: 0131 225 4324
email: sales@luath.co.uk
Website: www.luath.co.uk

ILLUSTRATION: IAN KELLAS